WATERCOLOR:
Go with the Flow

WATERCOLOR:
Go with the Flow

GUY LIPSCOMB

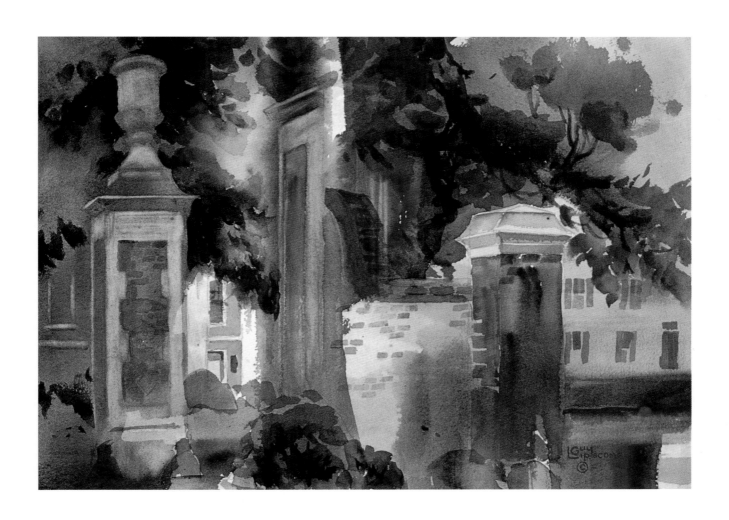

WATSON-GUPTILL PUBLICATIONS/NEW YORK

Art on title page: *OLD HORSESHOE.* Watercolor on Arches 140 lb.
cold-pressed paper, 22 × 30″ (56 × 76 cm). Collection of the artist.

All the art in this book, unless otherwise noted, is by Guy Lipscomb.

Copyright © 1993 Guy Lipscomb

First published in 1993 in the United States by Watson-Guptill Publications,
a division of BPI Communications, Inc.,
1515 Broadway, New York, N.Y. 10036.

Library of Congress Cataloging-in-Publication Data

Lipscomb, Guy.
 Watercolor : go with the flow / Guy Lipscomb.
 p. cm.
 Includes bibliographical references and index.
 ISBN 0-8230-3189-6
 1. Watercolor painting—Technique. I. Title.
ND2420.L56 1993
 751.42′2—dc20 92-34438
 CIP

Distributed in Europe, the Far East, Southeast and Central Asia, and South
America by RotoVision S.A., 9 Route Suisse, CH-1295 Mies, Switzerland.

Manufactured in Singapore

First printing, 1993

2 3 4 5 6 7 8 9 10 / 97 96 95 94

DEDICATION AND ACKNOWLEDGMENTS

Among the best-remembered people in anyone's life are those whose words have inspired you to think—those who send you off on an unexpected tangent into a brand-new area of exploration.

There is no great virtue in being a self-taught painter, just as there is little joy in reinventing the wheel a few hundred times. Life is much too short to spend time discovering what is well known and available to all who are willing to read and study and listen.

I want to thank again all of the following people who shared their knowledge with me over the years:

My mother,
Adelin S. Lipscomb

Don Andrews
Carol Barnes
Miles Batt
Ed Betts
Judi Betts
Glenn Bradshaw
Rex Brandt
Gerald Brommer
Al Brouillette
Carrie Brown
Marbury Hill Brown
Cheng-Klee Chee
George Cherpov
Virginia Cobb
Mario Cooper
Henry Caselli
Tony Couch
Keith Crown

Charles Crowson
Pat Deadman
Jeanne Dobie
Ray Ellis
Nita Engle
Edmund Fitzgerald
Douglas Grant
Dan Green
Robert Beverly Hale
Harry Hanson
Tom Hill
Serge Hollerbach
Joan Irvine
Dong Kingman
Everett Raymond Kinstler
Nell Lafaye
Robert Landry
Fran Larsen
David Leffel
Katherine Chang Liu
Katherine Marshall

Maxine Masterfield
Jeanne McWhorter
Fred Messersmidth
Robert Mills
Mark Moon
Charles Movelli
Dale Myers
Tom Nicholas
Ruth Ogle
Eliot O'Hara
John Pellew
Gil Petroff
Marilyn Hughey Phillis
John Pike
Carlton Plumber
Alex Powers
Nicklaus Reale
Charles Reid
Marilynne Roland
Boyd Saunders
Christopher Schink

Betty Lou Schlemm
Bud Shackleford
Irving Shapiro
Millard Sheets
Georg Shook
Mozelle Skinner
Ralph Smith
Jim Stevens
Don Stone
Paul Strisik
Val Thëlin
Oscar Velasquez
Janet Walsh
Frank Webb
Millard Wells
Ed Whitney
Joyce Williams
Jason Williamson
Robert E. Wood
Milford Zörnes

I learned from each of these generous people, and this book is dedicated to them with the hope that others will find the joy and satisfaction I have found exploring ways to communicate in paint.

I would also like to thank those at Watson-Guptill who helped with the development of this book: Candace Raney, Janet Frick, Areta Buk, and Ellen Greene. I am grateful for their assistance.

Contents

Introduction

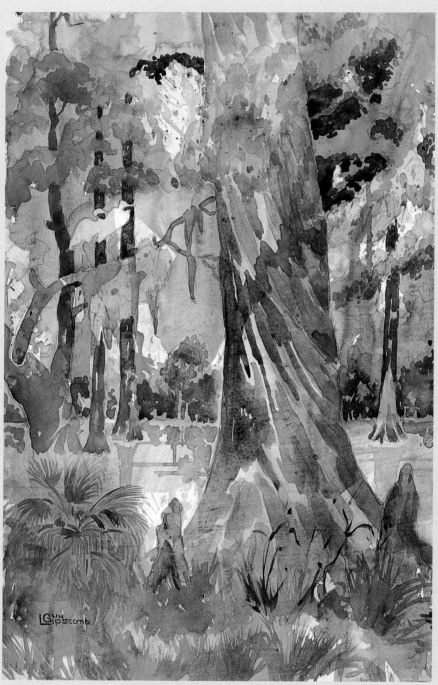

QUIET PLACE. Watercolor on Arches 140 lb. cold-pressed paper, 30 × 22″ (76 × 56 cm). Private collection.

> *"As music is the poetry of sound,*
> *so is painting the poetry of sight."*
> —James McNeill Whistler

I began writing this book as the result of my own gnawing impatience for answers to basic technical and aesthetic questions on how to go about becoming a qualified painter. While on this journey, I became indebted to the generosity of more than fifty contemporary painters and have tried to absorb some of the wisdom of at least that many painters of the past. This book is the result of this composite knowledge coupled with my own experiences, reflections, and analysis over the past twenty-five years.

When I started studying watercolor 1967 with instructor Eliot O'Hara, I felt not only at sea but floundering around in the undertow. The following little poem, which I wrote in 1975, expressed my constant feeling in my early years of effort. However, time and diligent work have removed some (though not nearly all) of the anxiety from the painting process for me. It is the fun of trying that makes it all worthwhile—so keep your brush wet!

MY PAINTING
Enormous white sheet
Empty, stark and silent
Where do I begin?

Vast white sheet
Afraid? Who me?
Afraid—indeed!
Frozen! Petrified!

Is my concept right?
Does my content appeal?
Should values be strong?
What will textures reveal?

All will be lost
If design is poor
How far to take it?
Should I study more?

My confidence wanes
But I finally plunge
ONE BOLD STROKE
Ah, YES! One I approve

The ice is broken
It's much easier now

Putting that first mark on your page is harder than stirring two-day-old oatmeal. All watercolor painters have had the fear of ruining a perfectly good surface by painting one false stroke.

My job in this book is multifaceted: to help you kill those fearful dragons; to help you erase your blackboard and start fresh; to help you increase your optic and intellectual vision; to help you improve your creativity and inventiveness; and finally, to help you set realistic goals and guide you toward their realization. If I succeed in any of these, the effort I have spent on preparing in this book will not have been in vain.

Read this book with the firm belief that you can become a far better painter than you ever dreamed. Read it, however, with the belief that you *must* hold the brush and do it *yourself.* You must take the words and brushstrokes of the great painters and teachers to heart, and resolve to work at your craft.

Doug Walton, a fine teacher at Louisiana Tech University, stresses the necessity for the "3 D's"— desire, determination, and discipline. This last one, of course, is the bear trap that catches us all. (The number of reasons I can find for not getting started is amazing!) So if you are serious in your desire and resolve to work hard on the discipline, this book should help you. It should awaken concepts, designs, color combinations, and shape relationships in you that you didn't know were there. It will make you more aware of what you are doing every time you pick up your brush. It will not only improve your understanding of the technical aspects of painting, but start you thinking like a pro.

Getting Started: Materials and Tools

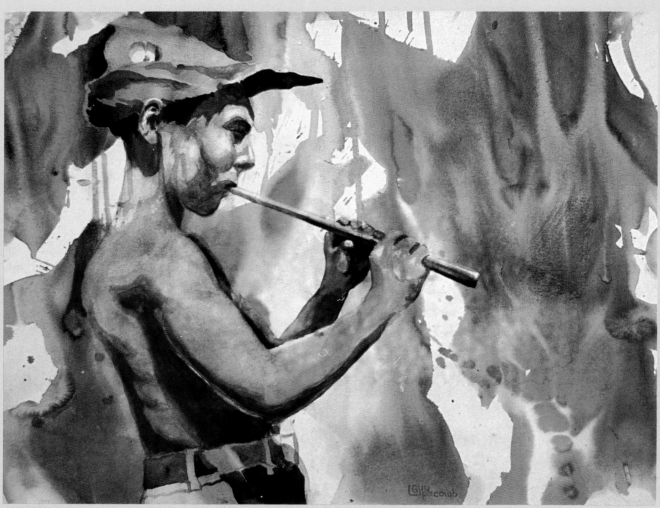

PIED PIPER. Watercolor on Arches 140 lb. cold-pressed paper, 22 × 30″ (56 × 76 cm). Collection of the artist.

"Nothing in this world can take the place of persistence. Talent will not; nothing is more common than unsuccessful men with talent. Genius will not; the world is full of educated derelicts. Persistence and determination are omnipotent."

—Calvin Coolidge

If you are just starting to paint, this chapter should be taken seriously, for it is written as the result of many false starts and errors in judgment on my part. Even an experienced painter might pick up a few ideas that will more than compensate for the reading time.

An experienced painter can pick up a stick in the woods and paint a wonderful picture! It's whose hand and mind has hold of the instrument that counts. We know this, but we all search for better tools and equipment, hoping to find a way to make progress faster. Good equipment and supplies will improve your work, and you should buy the best you can afford—while remembering that any tool is, at best, only the extension of your mind.

One of the first things I say to a new pupil is this: You will never, ever, paint your best if you are concerned at all about the cost of your paints and working surfaces. The result of this concern, that fearful hesitant stroke, will show and keep you from painting confidently and well. This is particularly true with watercolors, where timing and drying rates are so very important.

The easiest way to get over your concern for the cost of your supplies is to save your funds until you can buy a sizable quantity at one time. The security of owning a nice cache of supplies will ease your hesitation, and fearful strokes disappear!

I don't plan to spend a lot of time discussing equipment and supplies, but I will tell you what works well for me and why I use what I do. Let's look at the basic necessities first, and then a lot of extras that I have found handy for working outdoors, creating special textures, and so on.

PAINTING PROCEDURE

Most experienced painters in watercolor develop a routine in their painting procedure, and I am no exception. I like to have two water containers, one in which to clean dirty brushes and one for clean water to keep new brushloads of paint clean and pure. I try to follow a routine progression of moves in the painting process: (1) I clean my brush in the cleaning water container and squeeze or blot out the residual dirty water on a kitchen sponge or towel. (2) I dip the brush into clean water and touch the sponge or towel to get off the excess water. (3) I then reach for the paint or paints on the palette. (4) Next I reach back to the sponge or towel to remove the excess surface color from the brush. (5) Finally I touch the brush to the painting surface, all in that order.

I believe that this routine has helped me with my control of values and uniformity of drying rates in various areas of the work. As a beginning painter, I often put excessive amounts of liquid color onto the sheet and would have to sit around while it settled into the paper. My current routine eliminates this problem. It took me years to realize the value of such a routine.

Most of what is talked about in this chapter has to do with planned, designed pictures. This is because I firmly believe that you increase your chance of success if you do go the planning route. You can go other ways, however, with perhaps more risk but often more excitement.

Some people prefer an intuitive, spontaneous approach where they select their subject matter or inspiration and then design it directly on the working surface. The painting then evolves from your subconscious reaction to the idea. This approach works best if you stay in high-key and middle tones until the concept has crystallized. You can start with wet paper into which color is flowed, always searching for suggested forms and inspiration. Then begins the task of developing these forms. Tints and tones of color determine mood most of all. They should be considered from

the first brushload of paint. You will be using all the principles of design subconsciously and often to the advantage of your end product. We will talk a lot more about all this in later chapters.

BRUSHES

I recommend numbers 4, 6, 10, 14, and 26 rounds in synthetic or synthetic and natural blend brushes. In addition, I keep a 1/2-inch, 1-inch, 1 1/2-inch, and 2-inch (1.25 cm, 2.5 cm, 3.8 cm, and 5 cm) flat with me all the time, and perhaps a number 6 rigger for use on fine lines. A 1/2-inch (1.25 cm) flat short bristle brush is useful for scrubbing out errors, especially for softening dried stubborn staining pigments if you have made value errors. Synthetics have improved in recent years, and in my opinion the expensive sables are not worth the difference in price, especially during the early years of a painter's work. The main advantages of pure sable brushes are that they have greater capacity for holding liquid pigment, normally hold a good point, and are resilient and snap back into shape when applying the paint. I have found several synthetic and mixed fiber brushes that hold their points well, have good resiliency, and hold almost as much paint as the pure sables at a fraction of the cost.

If you ever make the mistake of leaving a brush in the water container overnight, the ferrule will loosen and the bristles may bend out of shape. To repair this, first take an ice pick or sharp punch and with a hammer punch a hole in the metal ferrule. This normally will tighten it up again. If not, pull it off the handle and use a little epoxy glue to hold it tightly again. Use a little laundry starch and fill the brush with the viscous material. Point it with your fingers and allow to dry overnight. Then wash out the starch and you should no longer have a curved brush.

I have recently become more interested in using spray methods of applying color. The airbrush, atomizer, and spray bottle all have their place in my work because they allow me to lay down graded color without disturbing paint already in place. The spray from the airbrush comes out as tiny droplets, deposited on the paper as almost instantly drying dots of color. When two colors are sprayed, the viewer's eye combines them; red dots followed by blue dots create lavender, with still a lot of uncovered white paper shining through.

Danger: When using an airbrush, always use a face mask and work in a well-ventilated area, preferably outdoors. Many watercolor pigments are very poisonous, and you will breathe the spray without knowing it.

PAPERS

For watercolor work I enjoy Arches 140 lb. hot- and cold-pressed papers more than any other, for several reasons. These papers have some transparency, and drawings can be transferred to them on a light box or sunlit window very easily. (More about this process later.) Some of the other all-rag papers on the market today are brighter and whiter than Arches, but I have found none that are as tough. Arches resists abrasion very well when you lift out color or change an area.

I frequently work out my designs first on 80 lb. or 90 lb. index paper, which I have cut at a paper supply house to 22 × 30" (56 × 76 cm) size. I recommend this paper for two reasons: (1) it is tough and you can erase and refine your drawing without danger of damaging the paper, and (2) you can see through it when you are making your tracing on a light box or sunlit window. I credit Doug Walton, a teacher at Louisiana Tech, for introducing me to this time-saver. I think its biggest benefit comes when you don't like what happens the first time you paint the piece. You don't have to reinvent the drawing: In a few minutes, you can trace your original drawing onto another painting surface and begin again. After all, your time is by far your most valuable investment in the painting.

Consider changing your painting surfaces to fit your subject matter. If you have made a decision to use some dry-brush areas or take advantage of granulating pigments in the piece, it would be wise to consider using a rough grade of paper. If you anticipate possibly doing a good bit of color removal, which is frequently the case for me when I do open-flow pieces, Arches 140 lb. papers (either the cold-pressed or the smoother hot-pressed) work very well. If you plan to paint large areas wet-in-wet, you may want to go to 300 lb. papers or Aquarius II, produced by Strathmore Paper Company, to help keep the paper flat during the painting process.

If you are a fairly new painter working on 140 lb. paper, it is often advisable to stretch your paper

before you start, since doing so removes one troublesome variable from the process. You no longer have to worry about the paper swelling up into little hills and the color running down into the valleys. One way to avoid having to stretch your paper is to use a dimensionally stable sheet called Aquarius II. This paper contains synthetic fibers that don't swell in water, so it remains much flatter when wet.

Rice papers are wonderful to work on when you want soft-edged forms. Most rice papers are produced in Japan (not necessarily from rice plant fibers) and are usually very porous, absorbent, and fragile when wet.

If you want to do a really large painting, you will be forced to use roll papers, which are available from Arches in rolls up to 52 inches (132 cm) wide and 10 yards (9.14 m) long. The problem with using these large pieces is that you have to build a sturdy frame or use a heavy piece of shielded plywood over which to stretch the prewet paper. You stretch the soaked paper just the way you stretch canvas on a canvas stretcher, always covering the wood where the paper touches it with aluminum foil, heavy polyethylene film, or several coats of gesso. This prevents any acid material in the wood from transferring into the paper and eventually staining the paper. Ordinary oil painting stretchers are strong enough up to 3 feet (91 cm) square, but larger pictures should have a heavier custom-built support frame. Once dried, the paper pulls up as tight as drum and puts a terrible strain on the wood supports.

Students are often talked into using student-grade papers for economic reasons. I feel that this is a mistake because it is almost impossible to do good work on poor-grade papers. If you really have to watch your supply budget, don't skimp on quality of paper or paints. When compared to the value of your time in study, preparation, and painting, these supplies cost little. What if you do a painting you love on a piece of wood-pulp paper that will quickly deteriorate?

PAINTS

Watercolor paints have come a long way in recent years. Most paint manufacturers have made rapid progress in pigment quality; they have had to in order to compete.

Just a few definitions for clarity: Paint is the entire substance you put on your brush. Pigment is the colored substance within a paint, usually a dry powder, that determines the paint's color. The paint is held together with some kind of medium, such as gum arabic, as well as a wetting agent and plasticizer to prevent the paint from drying before it is used.

Just as with papers, use the best-quality paints unless you are a rank beginner with no money. I do not use one manufacturer's products exclusively. Certain hues are available only from one manufacturer. Also be aware that paints sold under the same name by different manufacturers may not be the same hue at all.

Most manufacturers warrant the lightfastness and permanency of their pigments. Some types of pigments are more stable than others, but the colors are rated by the manufacturers, and their recommendations should be heeded.

Caution: Many pigments are poisonous and should not be ingested. (I've had students who were pointing their brushes with their mouths—a dangerous practice! Read the manufacturer's literature on whatever you are using. In my most recent literature from major manufacturers, I noted for the first time that the Art & Craft Materials Institute has required that all manufacturers are required to issue cautionary health statements as recommended by the American Society of Testing Materials. Also, be sure to use a good mask when using an airbrush or handling any dry pigments, so that you do not breathe toxic particles.

I keep a lot of different colors available, but use a basic palette most of the time. I use the symbols in the right column to jot quick color notes when

TIPS

- To slow down evaporation of watercolor on dry days, put a dozen drops of glycerin in a cup of your mixing water.

- To speed up drying on wet days, mix rubbing (isopropyl) alcohol into your painting water. The amount to add will vary depending on the humidity, but a half-and-half ratio will increase drying speed even on rainy, humid days. Practice so that you know what works best under different weather conditions.

I'm doing rapid drawings on location; you'll see examples of this later. Of course you can invent whatever notation system works best for you.

Color	Symbol
New gamboge (a warm yellow)	NG
Cadmium lemon (a cool yellow)	CdL
Cadmium red light (a warm red)	CdRL
Alizarin crimson (a cool red)	AC
Ultramarine blue (a warm blue)	UB
Phthalo blue (a cool blue)	TB
Cobalt blue (a neutral blue)	CoB
Cerulean blue (an opaque blue)	CeB
Viridian (a neutral green)	Vir
Phthalo green (a cold green not found in nature)	TG
Raw sienna (a grayed yellow)	RS
Yellow ochre (a grayed yellow)	YO
Ivory black (a black)	IB

PALETTE

I have tried half a dozen, and I like an enameled butcher tray best because it never stains, although it is much heavier than my second choice, the Pike Palette.

For on-site work, I like the Pike Palette, which has a sturdy cover and wells that do not hold water. This reduces the contamination of one paint by others in the mixing process. The artist simply drags the paint from the well into the main mixing area, and they are mixed with water only there. This minimizes contamination of the main "stockpiles" of paint.

Always, always, always put out fresh tube color each time you paint! This will allow you to put down strong, vibrant color when you want to and not wear out your best pointed brushes trying to get up intense color from dried color. Fresh tube color enables you to control intensity of color and values much more easily. You will not be constantly killing your transparency by having to go back over an area to get the values you want. *This is probably the most common judgment error of watercolor painters.*

OTHER USEFUL ITEMS

A sketchbook is crucial for any artist's development. Always keep your notebook or sketchbook with you. It's the place to record your ideas, designs, and drawings and should never be left behind.

A French easel is a great convenience for working outside because its legs can be adjusted to fit any terrain and it folds up into a compact carrying unit. However, when loaded with paints and gear, the easel becomes quite heavy.

A light box, which you can easily build for yourself using the design included here, at a fraction of the cost of a light box this size. It's great for tracing drawings onto underpaintings, as well as for evaluating and collating slides and transparencies.

An airbrush is a very useful tool, as mentioned earlier. Consider it especially when you are painting on hot-pressed or gesso-coated surfaces and you are concerned about disturbing the first layers of paint.

Several cellulose kitchen sponges are very useful to take off the excess paint and moisture from your brush before you go to your work surface. This way you avoid putting too much liquid color on the page at once and having to wait for it to dry before proceeding.

A piece of natural sponge can be used as a brush. You can get a variety of line widths because of the different fiber lengths in the sponge. I attach sponge pieces to the ends of old brush handles.

An elephant-ear silk sponge is a great tool for softening edges and erasing wet passages. Rex Brandt, a California painter and former teacher of mine, introduced me to the multiple uses of this painting tool, which he likes to keep in his left hand while working.

A refrigerator! Surprised? It is a great protector of paints on your palette. After working, I usually close or cover my palette (with a wet cellulose sponge enclosed inside) and slip it into the refrigerator to prevent mold growth on the paints. A few drops of rubbing alcohol on those colors that mold most easily will help preserve them. However, I always add fresh color on top of what remains in each section of my palette, even if the old color still seems soft and workable.

A small hand mirror is a useful tool. Holding the mirror over your shoulder and looking at your work in reverse often helps you spot errors in shape, value, or color that you might not pick up looking at the piece straight on. Do this several times during the painting process.

A reducing glass comes in very handy when you are working in crowded quarters, such as a

A HOMEMADE LIGHT BOX

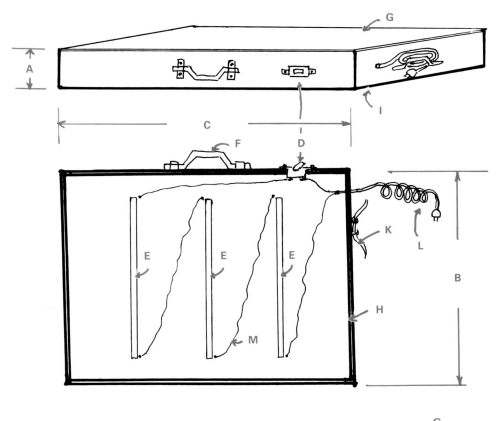

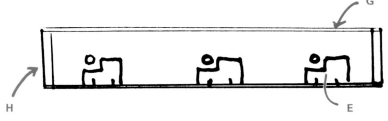

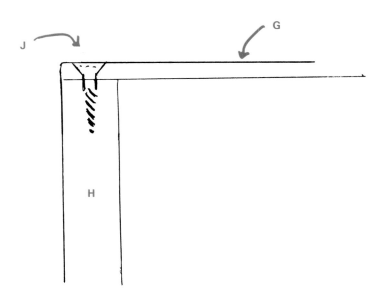

You can build your own light box large enough for a full sheet (22 × 30", or 56 × 76 cm) of watercolor paper. To buy a light box this size is a lot more expensive!

A. The height of your light box depends on the height of the fluorescent fixtures you buy. Fixtures range from 1" to 3 ½" (2.5 to 9 cm) high and can be bought at hardware or home supply stores. The height of A should be at least 1" above the fixture tube.

B. Box width: 22" (56 cm).

C. Box length: 30" (76 cm).

D. Snap switch with one wire entering and one wire leaving.

E. Three 18" (46 cm) under-shelf fluorescent fixtures with tubes in place. Attach the fixtures to the plywood bottom with small screws or bolts.

F. Carrying handle, which can be made of rope or purchased and attached with screws.

G. White Plexiglas, ⅛" or ³/₁₆" (.32 or .48 cm) thick and 22 × 30". Available from outdoor sign companies.

H. Sides of box are of soft white pine or spruce, ¾" (2 cm) thick.

I. Bottom is 22 × 30", of ³/₁₆" plywood. Nail or glue it to sides.

J. Countersink small ¾" bevel screws through the Plexiglas into the side. There should be four on each of the four sides of the box.

K. Cleat for wrap-around storage of the electric cord.

L. 8 to 10 feet (2 ½ to 3 meters) of wire extension cord. You can use one wire of the two and connect up the lights on a single insulated wire.

M. Inside the box, wire the fluorescent fixtures in series. Plug the extension cord in and you are in business.

workshop or classroom situation where you can't get away from your work to view it from a distance. The reducing glass pushes your painting about ten feet away so that you get a much better feel for the whole page at one time without having to move at all. Alex Powers, a painter and teacher from South Carolina, introduced me to this helpful tool.

A trial mat is a big help during the painting process. If you isolate the piece by holding up a mat to "frame" it several times as you are painting, you will get a fresh view and a better evaluation of your work, often discovering things that need to be changed. It also helps in the decision to know when to stop!

Films are wonderful textural devices and shape makers when placed into wet washes. Many kinds of film can be used: Saran Wrap plastic wrap, vinyl, polyethylene in various thicknesses. Also try bubble wrap and positive and negative shapes cut from embossed or perforated film. All will produce interesting shapes and textures when placed and hand-manipulated in wet washes. They can be left for a few minutes or left to dry completely before removal. Early removal creates soft effects. Where film touches the paper and dries, the color will be darker and more intense. Where it does not touch the paper, the paint will be much lighter in value.

Vinyl film, either adhesive or nonadhesive, is very useful for making your own stencils. After you have made the drawing of the shape you want, place the clear film over the drawing and cut out your own stencil with a stencil knife; then use it to create a positive or negative image.

Red acetate film is useful for checking values. When you look through it at your painting, it wipes out all color and you see only values.

Heavy, clear, wettable acetate film can be used as a monoprinting device. Paint a shape, and while it is still wet, cover it with heavy film. Then transfer the shape-printed film to another location on the page and print the shape again. Each progressive printing will be less intense than the previous one. This technique is good for simulating rough ground.

Waxed paper creates a different texture from films because it is more moisture-repellent. It can be folded, crushed, or laid flat on wet washes and allowed to dry completely or partially with interesting results. It usually must be weighted down to make contact with the wet wash.

Aluminum foil offers another variety of textural opportunity when used like waxed paper or film in contact with wet washes.

A soda straw is useful for creating textures reminiscent of branches and weeds. Put a mounded spot of color on the page where the base of the shrub is to be. Then move the paper as you blow through the straw, and you can create many interesting branches and shapes.

Clear water applied to a wet color wash at various stages of drying with a fixative sprayer, Windex-type sprayer, medicine dropper, or toothbrush will all react slightly differently, producing interesting textures. Water can also be squirted onto your palette now and then to prevent the paints from drying out.

Rubbing alcohol applied into wet wash at various stages of drying—with any of the above tools or a soft brush—is a good texture device.

Acetone applied into wet wash with a medicine dropper, brush, or atomizer will give you an effect similar to that created by alcohol.

Ox gall is a wetting agent that will make textural shapes when dropped or spattered into wet areas. Several of my friends like to add it to their painting water to increase the movement of their paint in

Waxed paper can be a big time-saver when you need to reserve thin white lines, such as those found in lace curtains or an ornate wrought-iron fence or gate. Check your waxed paper; one side usually has more wax than the other. Place the waxed paper directly on the watercolor paper, waxier side down, and use a dull pencil or stylus to draw your design. Wax will be transferred onto your painting. Here you see a design I wanted to reproduce, and how it looked after I painted a blue wash over the wax lines. Now paint over the area, and your design will remain white. Paraffin wax will not hurt the paper in any way because it is inert and colorless. As with most special techniques, practice first. Waxed paper works best on fine lines and on smooth paper.

Soda straw painting is an easy way to get weed and desert forms and textures. Just take a soda straw and direct it at a wet paint spot. By blowing through the straw, you can design very interesting things. Practice first!

wet-in-wet passages. It causes the paint to spread more on the page because it lowers the surface tension of the water in the wash.

Table salt, kosher salt, and epsom salt will all create interesting shapes if sprinkled into a wet area that is just beginning to lose its shine as it begins to dry. Table salt will give small stars if the painting remains flat. Kosher salt gives more variety of sizes and shapes because of the irregular grain sizes. Salt shapes become much larger if they are formed on a sloping or vertical surface. All three types of salt textures are easily overdone, so use them sparingly—that is, when the star shapes they make really help depict the subject matter or mood.

Latex masking fluid is well known, but most painters don't take full advantage of its potential because they apply it only with a brush. Consider spattering it for texture. Use it on top of base washes, not just for protecting white paper.

TIP

- Most masking fluids are made of rubber latex, stabilized with ammonia. When you leave the bottle open while you work with the fluid, the ammonia evaporates and the latex begins to coagulate. To prevent this from happening, I always pour out into a cup the amount of latex I think I'll need, and I use household ammonia to thin it to the right consistency for brushing. I also put a few drops of household ammonia into the original container and recap it immediately. If you do this, you will be able to use up a container of masking fluid completely with no waste.

Gesso is a good resist and texture maker. It can be applied smoothly or with great texture by using paint rollers or rough and smooth bristle brushes. It can be applied as spatter, in broken patterns or uniform patterns. Always spray finished work done on gesso coated surfaces with mat fixative or diluted mat medium to waterproof it. Interesting effects can be achieved by adding granular material such as sand or sawdust to gesso and applying it to your painting surface. White acrylic paint and several acrylic mediums can be used in the same way as gesso with slightly different results.

Masking tape can be used to cover large areas of a painting. The best product I've found is 3M #230 drafting tape, which doesn't tear most papers upon removal. Most inexpensive tapes stick too tightly and can destroy your work when removed. In any event, remove the tape as quickly as possible after painting, since all tapes become more adhesive with the passage of time.

If no drafting tape is available, inexpensive masking tapes can be made less adhesive by dragging the adhesive side of the tape across your clothing to pick up lint, thus reducing their adhesiveness.

Matte medium can be used as a resist if applied diluted (two parts water to one part medium) with a brush. Allowed to dry, it prevents the paint from penetrating into the paper. I often use this treatment when I know I may want to lift color areas later. It can also be applied full strength out of the bottle or tinted with watercolor to obtain different effects. Try painting it into the paper as shapes or spattering, dripping, or stenciling it. You are limited only by your imagination. Matte medium can be printed from stamps made of your own design; these provide a background rhythm in your work. This is the technique I used here. (See page 70 for a finished painting done on a stamped underpainting much like this one.)

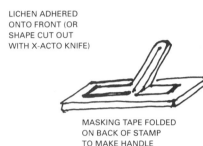

LICHEN ADHERED ONTO FRONT (OR SHAPE CUT OUT WITH X-ACTO KNIFE)

MASKING TAPE FOLDED ON BACK OF STAMP TO MAKE HANDLE

Try adhering small lichens, mosses, and other miniature organic forms to mat board. Paint the shape with a brush, wipe off any excess paint with a tissue, and then press the stamp in place on your painting.

You can also cut a shape into mat board with an X-Acto knife (like an etching, cutting about halfway through the mat) and then sand the mat board with fine sandpaper to get the edges of the cut area smooth and flat. Apply fairly viscous paint into the shape you have carved out, and it will print onto the paper. (I thank Nita Engle for contributing this idea to my collection.)

With either kind of stamp, fold masking tape on the back to make a handle. Just be careful not to overuse the same shapes so that they become repetitious. The stamps are best used to vary texture.

Elmer's glue can be used as a resist to watercolor. Apply it as a design or texture; it dries clear but can be tinted easily with watercolor pigments.

Antistick cooking spray and insect repellent spray are two interesting resists. Spray it on dry paper before painting or into a wet wash. Practice first.

Modeling paste made by Liquitex is often used to get a three-dimensional effect and can also be used as a resist. Because it is very high in viscosity, it can be shaped into almost any type of texture. It must be allowed to dry overnight before using it as a resist base. It too can be colored ahead of use.

Clothes marking soap or tailor's soap can be used to draw with or to completely mask out white lines or shapes. This material is made from a combination of hard wax and soap and will not harm the paper when it remains.

Wax crayons, oil pastels, and candles are other types of resists that can be used as drawing instruments. Melted paraffin wax can also be spattered or painted onto your surface to remain as a resist.

Handmade stamps are easy to make. Scratch a design onto a mat board with a dull knife. Paint into the design, clean off the excess paint with a facial tissue, and then print your design into light or middle-tone areas. You can also use stamps to apply matte medium as a resist. A good way to begin experimenting with stamps is to carve potatoes into the shapes you want.

Colored papers add a whole new feeling to a painting. You can use casein pigments and soak your papers, or brush colors on. Casein is waterproof when dry, so normal watercolor techniques can be used on papers colored with casein pigments. Acrylics can be used, but when followed by watercolor the watercolors do not take as well as when applied to casein. You can avoid having to bring back your whites with gouache by masking them with latex mask before applying color.

Permanent inks provide useful colorful opportunities. I have found the most reliable to be those made by the Steig Company. They have good

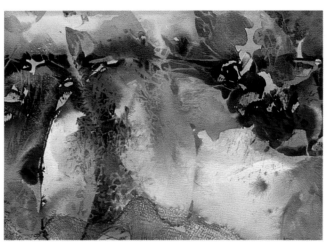

GENETICS. Watercolor and inks on Arches 140 lb. cold-pressed paper, 22 × 30 (56 × 76 cm). Collection of the artist.

Inks offer brilliant color and low viscosity, and they can yield wonderfully soft-edged forms in watercolor washes. Check the manufacturer's literature for lightfastness. All the inks used in this painting were made by Steig and have good resistance to light. Here I placed soft plastic wrap or vinyl films in the wet ink, manipulated them to make interesting shapes, and let them dry. This process produces odd shapes that can look mechanical and sometimes have to be modified or pulled together with a brush.

stability when exposed to light. Experiment with whatever inks you like, and check their lightfastness ratings. Some inks cannot be painted over in watercolor because their binder is some type of soluble resin that becomes insoluble when dry and is hard to paint over except with acrylics and other inks. Experiment with inks and watercolors first before you try them on a painting you care about.

Gouache (opaque white watercolor), ink, and acrylic are worth exploring. They can be used to recover white areas that have been lost, or to spatter on dry watercolor to give the texture effect on falling snow. Also try them as a spatter or spray in a wet wash to create a different texture with quite soft edges.

Open-mesh, lacelike fabrics, ribbons, and string, as well as natural growing materials (grass, flowers, leaves, weeds), offer endless opportunities for eye-catching textures. Just place them in wet washes, cover them with waxed paper, and weigh them down until dry.

Scraping, scratching, or pushing wet paint with a variety of tools will also create appealing textures. There are all sorts of things you can use: palette knives, pocket knives, credit cards, bits of mat board, fingernails, and scrub brushes, to name just a few.

If you press hard enough into wet washes with the side of a dull knife, the color will go into the damaged area and produce a dark line. However, if you press lightly and push the color aside, you can create light shapes in your wet area. Both must be done while the color is still wet on the paper. Practice to know when and how to get each result.

Screen wire (window screen) can be loaded with one or more colors. With a little practice, you can then place paint droplets just where you wish on your painting surface by holding the screen about 6 inches (15 cm) away from the paper and blowing through the screen in quick, short puffs. Protect surrounding areas by draping them with a towel.

By putting various sizes of fabric, metal, or plastic screens on paint that is completely dry and rubbing a wet, squeezed-out cosmetic sponge over the top, you can lift out the color in the holes of the screen and get the impression of the screen design. I always go back into this type of texture and paint out parts to disguise the mechanical look.

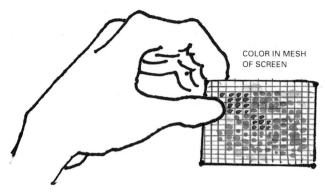

COLOR IN MESH OF SCREEN

Try using window screen to apply dots of color. This technique gives you much more control than spattering with a bristle brush. You can put one or more colors in the screen and deposit dots of different sizes by blowing puffs of air through the screen. Practice this technique before using it on a painting, and be sure to mask off surrounding areas with a towel.

Aquapasto by Winsor & Newton is a thickener for watercolor, which will give an impasto effect to your work.

Distressed paper can be used for interesting textures. It works best for me with Arches 90 lb. or 140 lb. papers because they are very tough. I wet one side of the paper and then start wadding the paper up, beginning at a corner and making sure it's crushing in both directions. I end up with a ball of paper. Because the paper is sized, you will break fibers along the creases, which will later take the paint differently. Spread the paper back out and wet it thoroughly on both sides. Then stretch it and staple it to soft plywood or Homosote board, a building board made of waste paper that can easily be cut with a hand saw. The distressed paper will flatten out on drying and give you a crackled, textured look when washes are applied.

Mixed media such as inks and acrylics—white, clear, or colored—become resists for watercolor and can be useful for textures.

The materials and supplies just listed work well for me. However, every painter has individual tastes, so some of my favorite tools may not work so well for you. The main point is to explore until you find a painting routine and supplies that make you comfortable, that bring out your best, that get your creative juices flowing. Then you will be ready to move ahead and *paint!* But first, let's take a chapter to look at drawing skills, which watercolorists need more than they sometimes admit.

To Paint Well,
First Draw Well

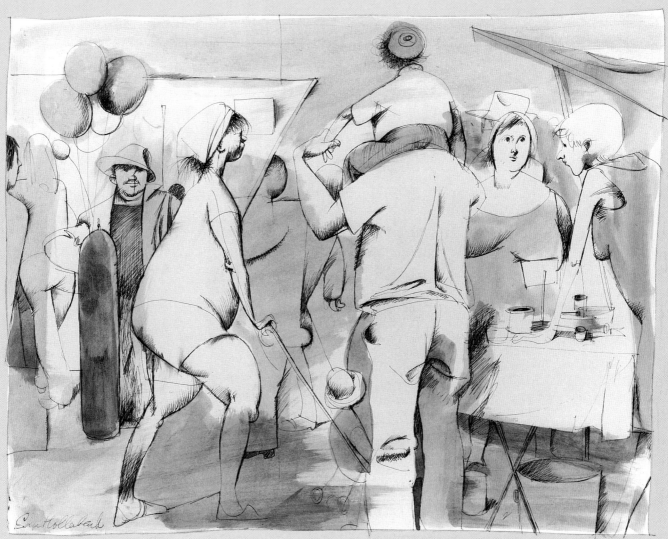

STREET FAIR by Serge Hollerbach. Pen, ink, and wash on paper, 14 × 17" (36 × 43 cm). Courtesy of Newman & Saunders Galleries.

> *"To look only requires one to open his eyes; to see requires a discipline. A botanist, a geologist, an ornithologist and a painter do not see alike because they look for different things."*
> —Rex Brandt

I believe strongly that the first skill required of a good painter is reasonably competent draftsmanship—in other words, learning how to see with the painter's eye and how to draw. I interviewed a number of fine painters, including Millard Sheets, Everett Raymond Kinstler, Rex Brandt, and Lamar Dodd, and found that they all emphasized the need for good drawing skills. This is true even if you are primarily interested in doing abstract paintings, partly because it is difficult to repair a watercolor painting if you make a false brushstroke. And yet a surprising number of painters do not draw very well. They are only handicapping themselves, limiting their own progress as watercolorists.

Good draftsmanship is an extension of your powers of observation plus the skill of manipulating your hand and eye. The better you can draw, the faster you will progress with your painting skills, and the more confidence and courage you will have to draw *what you want to see,* not necessarily what's in front of you.

Here are some ideas on getting started improving your drawing ability. First this will involve recording what you see; later it will involve interpreting it emotionally.

UNDERSTAND THE FOUR BASIC TYPES OF DRAWINGS

Information drawings are research drawings in which the artist investigates the construction of the object or subject. They are not concerned with the design of the drawing—that is, how to fit the information aesthetically onto the paper. They are most important in representational work, where the artist needs thorough knowledge of the subject matter.

Action drawings are done quickly, often in 10 to 30 seconds, and are meant to capture the rhythms of the moment in the subject. This type of drawing is great for warming up.

Design drawings determine the layout, size, shapes, and placement of shapes on the working surface. There are no details, just shapes and three values (white, middle gray, and black) and possibly suggestions of later color placement. I like to think of this design step as the foundation of the painting to come. It is the step where your originality and personal vision begin to separate your work from that of anyone else who has ever put a brush to a painting surface.

Drawings intended as finished products can be exquisite works of art in their own right, but they are not discussed in this book because we are focusing on watercolor.

DRAW SOMETHING NEW EVERY DAY

Are you serious about learning to draw well? Then resolve to draw every day, something you have never seen before, not just to record information but to make a beautiful gesture information drawing. You need to get into the habit of recording daily what you see around you. Just fifteen minutes a day will give your skills a real boost, and if you already draw well, it will keep you from losing what skills you have. (If you don't use, you lose!) As one great concert pianist expressed it, "If I miss one day of practice, I know it; if I miss two days of practice, the critics know it; if I miss three days of practice, the audience knows it!"

DO INFORMATION DRAWINGS

When I first began painting, I used to go out with my good friend and teacher Gilmer Petroff to do information drawings. I was always astonished by all the interesting material he would bring back from our trips—so much more than I did—even though we had viewed exactly the same things. Of course, the answer was his skilled artist's eye, which I didn't have. Until you become a superb noticer, a truly careful observer of the vital essence of what you see, you will be prone to make far too many judgmental errors in drawing, and you will miss many interesting shapes and relationships.

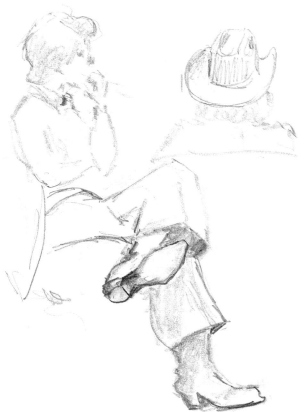

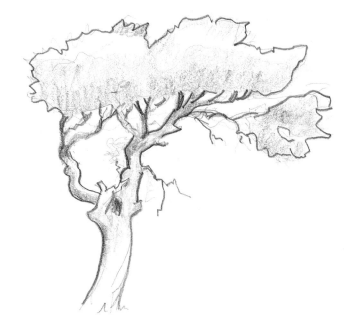

I was drawn to the graceful shape of this old oak, which was weathered by the sea winds. This information drawing explores its shape, especially the negative spaces between the branches.

This young woman was waiting at an airport in Texas, and I was intrigued by her cowgirl boots. You don't really know the shape of something until you've done an information drawing of it.

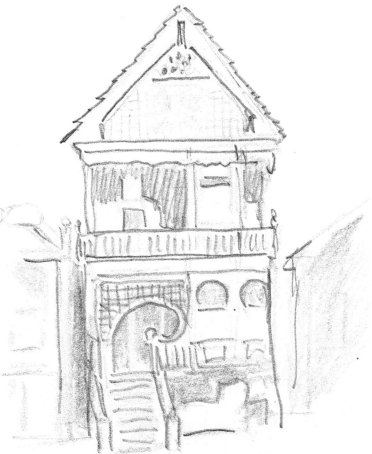

This house in Kansas City was sandwiched between two larger buildings. I loved all the gingerbread curlicues, so I did a quick information drawing to capture them. I've used this house in two paintings since.

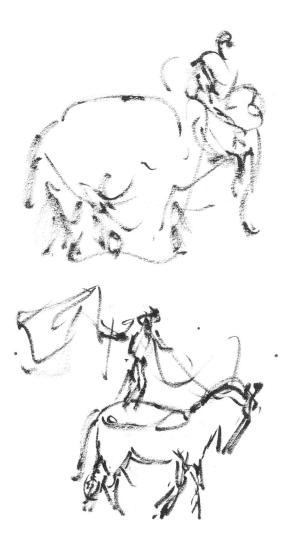

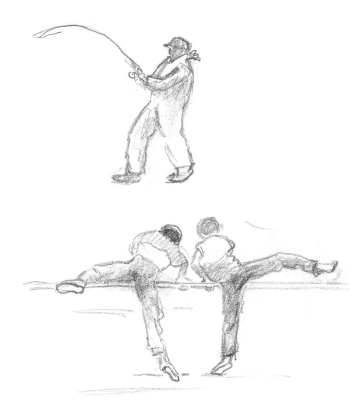

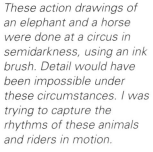

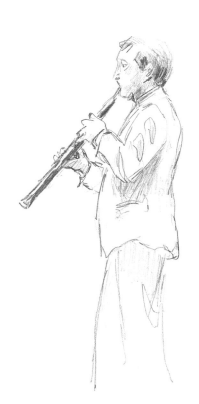

This fisherman was standing on a dock, and my action drawing studied the shapes of his body and the arched fishing rod. Fishermen are patient people, so they make excellent subjects. The boys climbing over the fence, on the other hand, would never have posed in this position. This action drawing was done from a photograph.

These action drawings of an elephant and a horse were done at a circus in semidarkness, using an ink brush. Detail would have been impossible under these circumstances. I was trying to capture the rhythms of these animals and riders in motion.

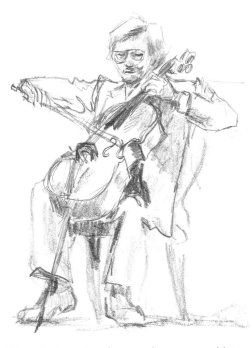

When I go to chamber music concerts, I love to capture the musicians' actions as they play. The more you do such drawings, the more adeptly you can draw the human figure even without a model.

These errors will weaken the sense of conviction in your paintings. This seeing ability allows you to show something really new about subjects that have been overlooked by most who have seen them before. The better you know your subject, the freer you are to concentrate on the aesthetic aspects of your drawing.

RECORD REMINDER NOTES WITH YOUR DRAWINGS

In recent years, I have been using a good grade of drawing paper cut and punched to fit a loose-leaf notebook, and I try to keep some with me at all times. The idea has served me well because I can collate a series of drawings for a specific painting project. I date each drawing and jot down in the margin what is happening around me at the time: the sounds I hear, the mood I feel, the thoughts in my mind, the weather, the time of day, the type and location of the light source, even the smells in the air.

When I get back to the studio, all these notes will help me recall the excitement I experienced on location if the work can't be completed there. Implications intrigue the eye and the mind far more than direct statements. This is why sketches accompanying notes are so important: They stimulate fantasies and expectations and leave the fulfillment up to your imagination.

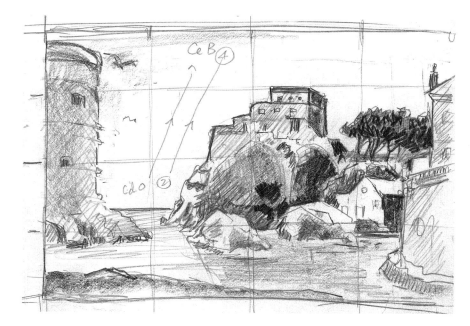

In this design drawing of a coastal scene at Dubrovnik, Yugoslavia, I concentrated on the most interesting silhouettes and size and shape relationships. In any landscape you must decide what to omit. You can see my color and value notations, as well as the lines with which I divided the drawing into sixteen equal sections. This type of information is useful later.

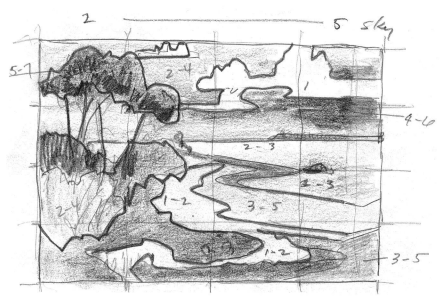

This design drawing of a coastal seascape focuses on interlocking shapes of trees, water, land, and clouds. The numbers stand for values or value ranges. Texture and color would make a lot of difference in this kind of design.

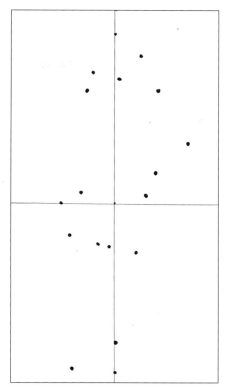

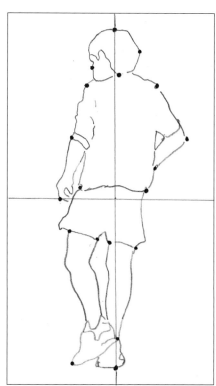

Establish a center vertical and horizontal line when you begin to draw a subject. You can then visually measure how important points relate to those two lines, thus establishing the overall proportions and balance of the figure. As soon as you begin to join your dots, you can see needed changes and refinements.

I also record, on the edge of the drawing, values on a scale of 1 to 10 (with 1 being white and 10 being black). I use arrows to indicate the location of the value number. When areas change in value, I mark "3–5" to signify a moving value in that area. I often record by the drawing the local color as well, using abbreviations such as YO for yellow ochre or RU for raw umber. This helps me recall the colors later if I don't have time to do the piece at that moment. I may not have any interest in using local color, but I will have a record if I want it.

Some painters believe that you should throw your drawings away. A drawing is one stage of the painting process; it is of no more use as soon as the painting is completed. I concur on the danger of repeating the same ideas in later work, but drawings are invaluable if you are not happy with your first try at the painting process. Watercolorists must skate on thin ice many times, and one poor decision can destroy the piece. It's comforting to have a well-designed drawing at hand, so you can start over. Also remember that by changing the color chord, emphasis, and center of interest, you can use the same basic design and come up with a completely different painting. Think of Monet!

IMAGINE THE DRAWING FIRST

Rodin's teacher made him go over the edges of the subject with his pencil in the air with his eyes open, then repeat with his eyes closed. He repeated this procedure several times before trying to make a drawing. He really was trying to get inside the subject, completely understanding the shapes, the subtleties of every part.

Try to picture the whole drawing on the page before you start. Then try to trace your picture on the page with your finger. You are making a size decision. The next step is to put a dot at the top center of your subject and drop a line vertically from that dot. Then establish critical spots on your page, spots that will help you measure the distance between critical locations on the subject material as well as their relationships to the vertical line.

Next establish an overall shape into which you can work your major shapes. It might be a geometric shape such as a circle, triangle, oval, or rectangle, or it might be an organic shape you invent.

Then add in a line that denotes the movement in the subject matter, especially if there are figures involved. Next begin to draw very light lines as you interpret the shapes. Sigmond Abeles, a fine drawing teacher, suggests that artists should start

drawing where the subject touches the ground, rather than at the head, realizing that most shapes have weight and direction that should be analyzed before you start to draw. Work out the shapes closest to you first and begin to tuck the other shapes in behind.

COPY DRAWINGS OF THE MASTERS

Boyd Saunders, art professor at the University of South Carolina, had us copy drawings of the masters each week in our sketchbooks. I learned from each one I did, and the lessons made me so much more aware of the variety of rhythms and beauty of line. I became a much more accurate viewer of all subject matter.

DRAW WITH DIFFERENT MEDIUMS

The most flexible, plastic, forgiving drawing medium is probably soft vine charcoal, and very sensitive work can be done with it. However, it is a good idea to change drawing instruments as you practice, since every different drawing device will give you a different quality of line. In your next drawing, discard your charcoal or pencil and try one of these:

Ballpoint pen
Felt-tip pen
Pen and india ink
Spatula and india ink
Twig and india ink
Number 8 round watercolor brush

Drawing in ink forces you to increase your powers of observation. An erasable medium is too often a crutch for poor concentration, poor observation, and indecision. So if you want a challenge, avoid the eraser temptation and draw in ink!

DESIGN THE PAGE

Make size or mass decisions and exhaust your ideas on how best to present the material that excites you. I like to make 3 × 4" (8 × 10 cm) three-value (white, middle gray, black) thumbnail sketches with a soft pencil. Because these can be done in one or two minutes, I suggest doing a number of them. If this material is really exciting to you, go ahead and exhaust your ideas on ways to design the page.

I will almost wager that the first design you make will not be the one you select for the finished painting. I've made as many as a dozen of these for one subject before deciding which one or ones work as a painting design. If I like more than one design, I try them in paint. So much happens when you start to paint that you may be surprised at the designs that excite you the most. Remember, *you cannot ignore color* when deciding on design or size of shapes in a design. I often enlarge the best small thumbnail design into a 5 × 7" (13 × 18 cm) line drawing, using either an opaque projector or a grid drawing technique. I then copy this line drawing four or five times using a light box or a photocopy machine and proceed to try out various color chords on the small 5 × 7" line drawings. I usually use 140 lb. watercolor paper for these little paintings, and sometimes they are better than the later large piece! They are often appreciated by the buying public as well.

Color chords are visually pleasing color combinations on which paintings can be built. In choosing a color chord, you need to make the following decisions:

1. What colors will create the mood desired?
2. Where will the major center or centers of interest be in the design? Color can help you establish this.
3. Will you use the local color of your subject? Many painters deliberately avoid local color.

(For more about color chords, see page 81.)

After I have decided on the color chords I want to use, I project the 5 × 7" drawing onto a full 22 × 30" (56 × 76 cm) sheet of index stock in line form, correcting or modifying the drawing as needed. This full-size outline drawing is then traced on the light box to good paper, and I'm ready to paint. I often make several large paintings from one small design, painting each with its own mood, emphasis, lighting, and palette, often adding or deleting elements that I think will make the painting more interesting. This procedure I have outlined above takes place in the studio after I have made on-site information drawings in the field to learn my subject.

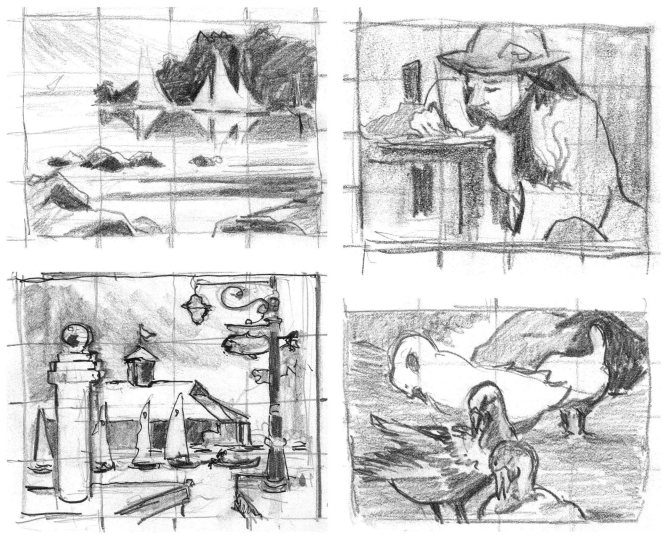

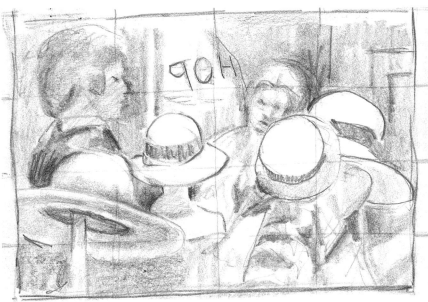

Here are several three-value (white, gray, black) design thumbnail drawings, each attempting to determine the best way to handle exciting value and shape relationships within the overall working surface. After I finish each design, I divide the drawing into rectangular sections. This will help me enlarge it later.

For on-site painting I don't have all these options, and I often roll all these processes into one. I usually work fairly small in the field, often 11 × 15" (28 × 38 cm) or smaller. I design right on the surface I plan to paint, using light pencil lines. I have to decide on a palette, right or wrong, and push forward because light changes so fast and I don't have time to experiment.

When designing your thumbnail drawing, draw hard-edged, clearly defined shapes and values, not ambiguous shapes. You can create your variety in edges, overlaps, color, gradation, textures, and so on when you actually paint the piece, but don't be mushy in your planning stage.

Every line in your big drawing should be committed to producing size and scale conviction, but once the painting process begins, the lines are no longer sacred and should be lost and found as the mood and design demand. *The big* mistake is to paint only up to the line, because an appliquéd, cut-out, fractured look will result. Paint across lines, creating a transitional two-color zone to avoid the collage look. Use overlapping and interlocking shapes to weave your painting together.

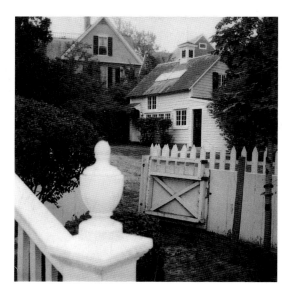

If you are judging by eye alone, it is tricky to enlarge your 3 × 4" (8 × 10 cm) thumbnail-size value drawing to the size of a full sheet of watercolor paper without errors in scale, particularly when you are working in the field. The grid method is easy, fast, and accurate enough for most needs. First divide the 3 × 4" drawing into 16 rectangles— four down and four across, each measuring 1 × ³/₄" (2.5 × 2 cm). Then divide the 22 × 30" (56 × 76 cm) full sheet of drawing paper the same way, but instead of drawing lines on the paper, put dots at the corners of the rectangles so that they will be easy to erase later. You will have sixteen rectangles measuring 7¹/₂ × 5¹/₂" (19 × 14 cm).

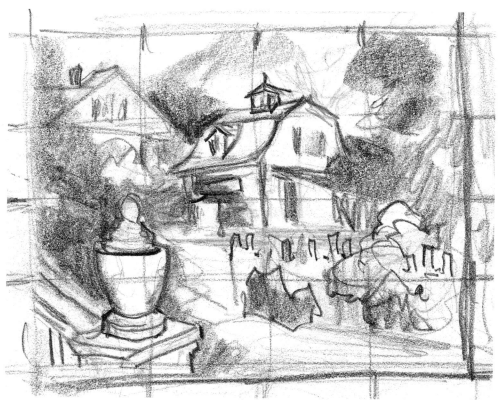

When you begin your drawing, don't forget that you already have four lines to deal with: the four edges of the work surface, which create four corners. So remember that corners are important to the success of your composition. They should be well thought out, different, designed to keep the eye from leaving the page. When you think design, don't draw information first. Allocate space and direction first. As Rex Brandt put it, "Let your lines go extending and seeking to create a scaffold of verticals and horizontals to secure minor elements."

THINK IN SHAPES, NOT THINGS

Poetic shapes, symbols, and short condensed forms will make your paintings live and breathe your own individualism, your style. Many great painters can be recognized by their icons—their shape vocabulary as well as their color chords and type of brushstrokes.

The better draftsman and designer you become, the more successful you will be at making your paintings work. Every painting you do is your real mentor, and we all learn more from our mistakes than from our accidental successes.

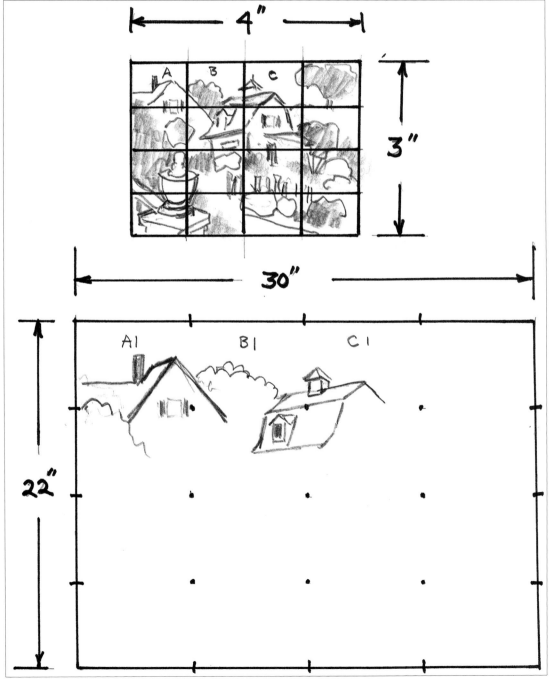

Once you have finished your small drawing, proceed to draw lightly on the big sheet, copying what is in box A (top left) of the thumbnail design into the corresponding box A1 of the big sheet, and so forth across the drawing. You won't be far wrong if you look hard and draw carefully. In the studio, I can use an even easier method: I often put the 3 × 4" value drawing on my opaque projector and project it directly onto my working page, where I can draw it at exactly the size I want.

The Open-Flow Method

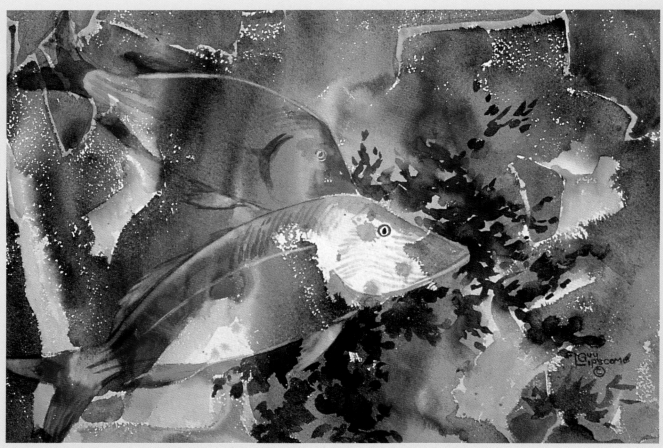

ANOTHER WORLD. Watercolor on Arches 140 lb. cold-pressed paper, 15 × 22" (38 × 56 cm). Collection of the artist.

> *"The secret of a fine painting is to render the invisible.*
> *In a work of art, it is only the spirit which shall be visible. The physical*
> *aspect is hidden and mysterious and we must struggle to find it."*
>
> —*Albert Gleizes*

W ho doesn't like a bit of mystery, provided it's solvable? If this statement fits you, you may well enjoy what I call the open-flow method of watercolor painting. My reason for choosing this name for it is that the colors flow freely into one another, and the finished paintings are open to the viewer to complete, to wonder about, and to interpret. Putting an unknown by a known— something implied by something more clearly visible—always helps generate interest by allowing the imagination and the subconscious to participate. I enjoy this approach because every painting is a new riddle to be solved, by you as the artist and by the viewer of the finished product. In addition, it often lets accidental invention work in your favor.

These paintings have a different look from work done in any of the conventional watercolor painting methods. They provide an unconventional surprise element for the viewer that adds both mystery and a new look to the painting, new exciting unplanned shapes and modulating colors in unexpected locations. Properly done, the open-flow approach does not destroy unity or harmony in the work, but adds to intrigue and discovery by the viewer. You will find yourself going back into the painting over and over, discovering new shapes, color chords, and intriguing relationships. There is nothing photographic about this approach; it gives a fresh look that I enjoy and believe you will too.

Open-flow paintings have a special element of counterpoint supporting and complementing the main design. In music, counterpoint is defined as the art of adding a related but independent melody or melodies to a basic melody, in accordance with the fixed rules of harmony, to make a harmonic whole. The real origin of counterpoint in painting goes back to cubism—Braque and Picasso and their school. The arbitrary undertones and shapes add another melody of color, value, and pattern to your pictorial theme.

THE BASIC OPEN-FLOW METHOD

Liquid color applied with a wide brush to a tilted paper creates nonrepresentational shapes as it flows around white, hard-edged, dry areas at random. Color mixing takes place on the paper, using the forces of gravity, to form a beautiful underpainting. You can then submerge this imagery as little or as much as you wish when you paint your main design over it.

I like to use cold-pressed and smooth hot-pressed papers because they allow me to lift color easily later in the process if I need to. If I decide I want the texture of rough papers, I often presize the sheet with one-to-one diluted matte medium and allow it to dry. If you contemplate a design that may require some lifting of color later, coat the paper with diluted matte medium several times before beginning to paint the underpainting. The goal always is to come up with an interesting nonrepresentational painting in its own right, with no goal as to how it might be used later.

Start your open-flow pieces using a large flat brush. I like to use a 2-inch (5 cm) brush on half-sheet 15 × 22" (38 × 56 cm) paintings and a 3-inch (8 cm) brush on a full sheet 22 × 30" (56 × 76 cm). Keep the painting surface on a slope of at least 20 to 30 degrees so that there will be a lot of downward movement of the liquid color on the page. The key is to have plenty of fresh, juicy color available on your palette or in small cups when you are ready to begin the underpainting.

CREATING THE UNDERPAINTING

Begin to paint intuitively with a goal of producing a pleasing nonrepresentational design, having no idea what will ultimately be the look of the piece. The only conscious decisions you should make at this stage are the following:

1. Decide whether the painting is to be dominantly warm or dominantly cool, and select the colors you want to use. In this type of work it is best not to use the staining or dye-based colors because you will probably want to lift or remove color out of some areas later on.

Most underpaintings will either be dominantly warm with a small amount of coolness or dominantly cool with a small amount of warmth. An alternative is to paint the underpainting with a dominance of neutral grays and depend on what is applied later for the color dominance in the finished open-flow piece.

2. If you start on completely dry paper, and I do about half the time, you can design the white unpainted shapes as you go.

3. Another variable to be thinking about is value. You are likely to have a much higher success ratio in the final painting if you keep your underpainting values lower than 4, with 10 being black and one being white. If values of the underpainting are too dark, there is likely to be conflict between the underpainting and the abstract or representational material added later.

4. Once you have begun your underpainting, it is very important to keep all the painted areas wet with flowing color until you are satisfied with your finished underpainting. Constantly feed the liquid color (with the large brush) into previously wet painted areas, allowing the color to blend and move by gravity on the sloping surface. *Avoid letting the brush mix the paint on the page.* I do this by touching the previously painted paper with a brush that has been heavily loaded with liquid paint, letting gravity do the mixing. Depending on the tilt of the paper, many beautiful flowing passages will be created that could never be produced using a conventionally brushed-on method. Tilting the page back and forth will cause the color to become overmixed and muddy. The most beautiful passages come when there is only limited mixing on the page.

The more vertical the paper, the faster the colors applied will move down and mix on the page. I enjoy the action of the oblique shape movements coupled with the dominant vertical movement of the color down the page. When I like what I see, I drop it flat and let the color settle into the page. Open-flow pieces can be so beautiful that leaving them as they are is quite tempting. However, I usually take them one step further by putting recognizable or abstract shapes into the nonrepresentational underpainting once it has dried. I often let the colors and shapes suggest the future of the painting, though I very seldom let the shapes dictate the subject matter. More often, I let the shapes and colors dictate the mood I want to convey.

To begin an open-flow underpainting, paint random shapes, leaving dry, unpainted shapes of random size where centers of interest might be. Keep the paint wet so that it will blend with the next color. In this case I am starting with pale yellow ochre.

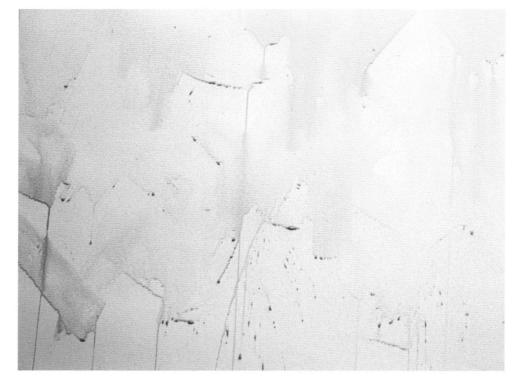

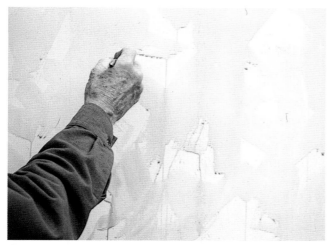

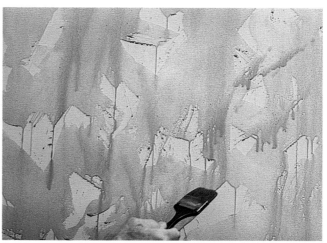

Continue the process, designing the dry areas for interest, shape, size, location, and direction.

Begin to change to your next color. (In this case I am using cadmium orange.) Always work from the top and allow gravity to mix the added colors on the paper. Make sure to keep all painted areas wet with color or water.

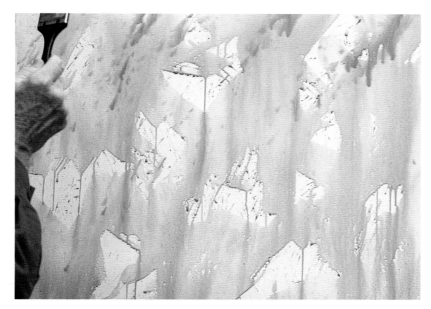

Now I am adding first cadmium red, then viridian green, by flicking or touching the color off the brush into the wet areas. If the brush presses onto the paper at this mixing stage, it tends to overmix the color, and the sensuous partially mixed color is often lost.

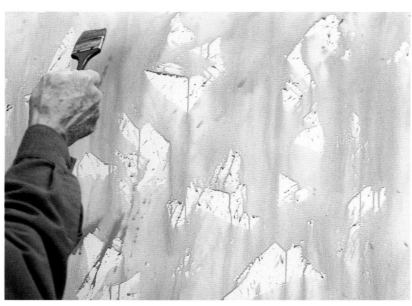

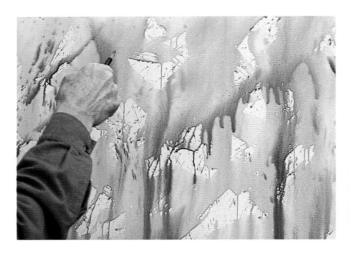
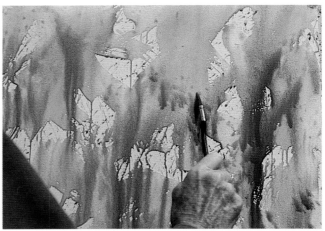
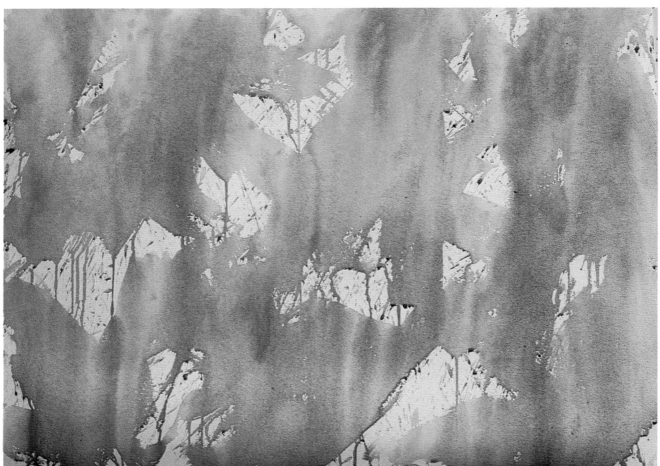

Permanent green and cobalt blue follow in the same fashion. The underpainting remains dominantly warm with accents of cool color, plus a number of interesting unpainted shapes.

EXAMPLES OF OPEN-FLOW UNDERPAINTINGS

I always study these open-flow pieces from all directions, including upside down and sideways. Frequently I have used them in a different direction from which they were painted. Many of these pieces remain in my studio for months before I find just the right use for them. My point is, if you are not pleased with your underpainting, don't discard it away right away. Let it hang around for a while and you may discover, after several weeks or months, that it's just right for a certain new idea and drawing.

At times the underpainting itself will suggest the type of subject matter that should be used in it. When this occurs, I immediately begin drawing shapes that might carry out the mood or feeling that I got from the underpainting. I must quickly say, however, that most of the time my ideas start with the drawing rather than the underpainting.

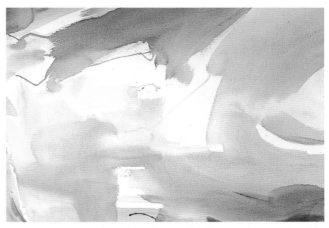

This underpainting was done on 140 lb. cold-pressed paper that had been prewet in some areas with clear water before color was applied. It was painted on a 25-degree slope to encourage movement of the pigments down the sheet.

Here is an example painted on an incline on dry paper with minimal pigment movement.

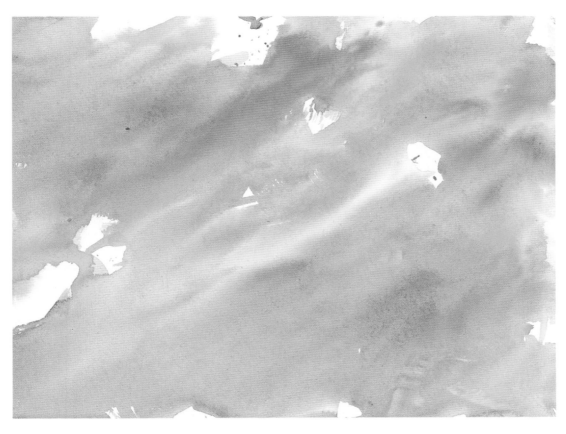

This time the paper was propped up on one corner, as well as tilted at an angle, to make the wet paint run diagonally across the page from one corner to the other.

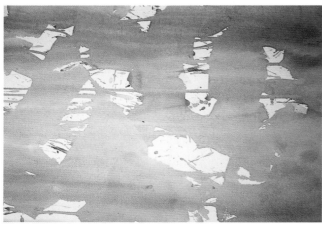

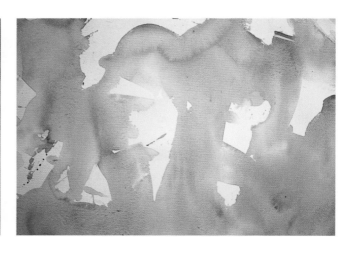

This underpainting was done vertically but later used horizontally to take advantage of the runs as divisions of space.

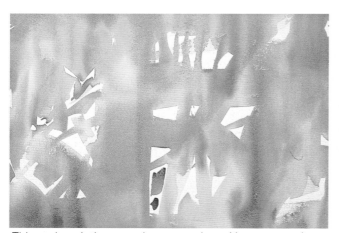

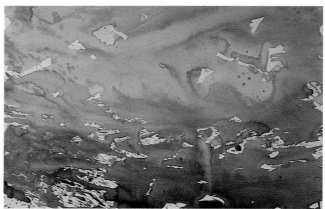

Here are two examples of painting flat on randomly prewet paper.

This underpainting was done on a slope. You can see the vertical streaks of color.

This was painted on dry paper with color movement within shapes. However, there are many light patches left. Such underpaintings are more difficult to use because they can look fractured, and many of the whites will have to be painted out. The size of the white patches is more important than the number of them, but both factors must be carefully evaluated and controlled.

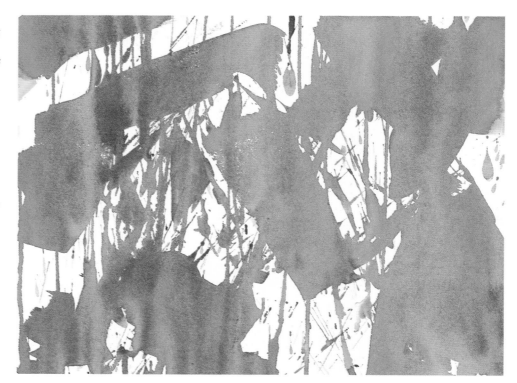

CHOOSING AND TRACING A DESIGN

Many of my designs start out as 4 × 3" (10 × 8 cm) three-value drawings, which I later enlarge to the size I will eventually paint. (A template cut out of mat board enables me to draw 4 × 3" rectangles in my notebook very easily.) To enlarge the drawing, I then use the grid method described on page 28 or an opaque projector, which is a nice tool to have to save time. I like to do these full-size drawings on 80 or 90 lb. white index printing paper, often using a 4B pencil on the final shapes to get them good and dark. That way they are clearly visible through the open-flow underpainting placed above the drawing, if both are on the light box or sunlit window. (The open-flow painting should be on paper of not more than 140 lb. so that some light will shine through it.)

Try various underpaintings on top of your drawing to see how they go together. I may try a dozen until I find one that seems to fit from the standpoint of color, mood, shapes, and location of lights and middle tones. The selection of the best underpainting to be used with a certain drawing is more intuitive than not, but here are the factors that dictate to me which underpainting will work best with a certain drawing design. The drawing design should:

1. Leave the most beautiful color passages in the underpainting untouched.
2. Use some of the unpainted white paper shapes as part of a center of interest in the painting.
3. Be reinforced and complemented by the movement and mood in the underpainting. (Several times I have tried to place a dominantly horizontal drawing into a dominantly vertical underpainting with no success.)

Using the light box, trace the drawing directly but lightly onto the selected underpainting. Now you are ready to begin solving your puzzle.

ADJUST VALUES, NOT COLORS

With the drawing now on the underpainting, you will find that colors have changed all around the page. There will be light and middle-value shapes in very unexpected places and of unexpected sizes. Try very hard to retain as much as possible of the underpainting's charm, by overpainting the subject matter using the colors already found in the underpainting. Simply change values—darker or lighter—to bring out new shapes without destroying the color of the old.

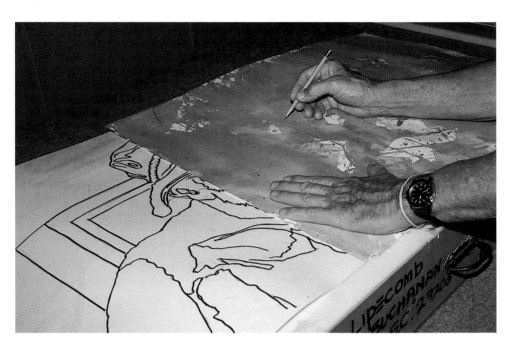

This photograph shows a bold design drawing on the light box with the open-flow underpainting placed on top. The drawing will shine through the 140 lb. paper, allowing it to be easily traced lightly onto the underpainting. (Here I purposely shifted the underpainting to the left so that you could see how I layered the pieces on the light box.) If a drawing doesn't show through well enough, try darkening it with a felt-tip pen.

For example, where the underpainting is red, paint the new shape on top a darker red. Where the underpainting changes from red to violet, change the subject on top from red to darker violet. It is often necessary to paint out some of the lights that have been left in the underpainting, or to lift color from some areas to make the new shapes read correctly. This method adds interest and excitement to your design by providing unexpected shapes, colors, and values.

The main danger in this approach is having the painting fractured by too many shapes and too many distracting lights. This can be minimized by making your underpainting shapes fairly large and your few dry white shapes smaller. I usually have to paint out or pull together shapes and values toward the end of the painting in order to achieve greater unity and harmony, being mindful to retain the excitement of the original underpainting.

TEN WAYS NEVER TO PAINT TIGHTLY AGAIN

It is relatively simple to paint an open-flow underpainting loosely and freely, because you are just letting colors run together to form appealing, nonrepresentational patterns. When you begin to paint your main design over it, however, you may be more tempted to paint with a cramped, inhibited style. There is nothing wrong or right about painting in great detail, but many young painters fall into the habit of moving the brush mostly with their fingers, a carryover from writing. These are ways to kick the habit when and if you want to do so for a bolder, freer look.

1. Use your largest, widest brush as long into the painting process as possible. You will be surprised how many wonderful shapes you can make with a big brush with a little practice. I like a 2- and 3-inch (5 and 8 cm) brush on 22 × 30" (56 × 76 cm) paper.

2. Paint holding the brush at arm's length. By doing so, you eliminate the use of finger movement and substitute arm and body movement for the tight writing motions of the hand and fingers.

3. Paint standing because you can get body motion and rhythms into your stroke. Or, if you are more comfortable sitting, keep your work surface at arm's length. Ed Whitney used to say, "Dance with your painting."

4. Paint against time. Designing your painting requires left-brain planning, but once you start to paint, jump right into the right-brain mode. How do you do this? Practice using a kitchen timer. Set it for 30 minutes first, then do the same design in 15 minutes, then again in 7 1/2 minutes. Doug Walton, a fine teacher from Louisiana, has his students go all the way down to one minute. You really would be amazed at the one-minute paintings. All the nonessentials have to be stripped away and the true essence of the material and design are left.

5. Paint across lines. By doing so, you get a combination of hues in the transition areas between shapes or planes, and this joins them in a very subtle way. As mentioned earlier, painting just *up to* the lines gives a cut-out, collaged look.

6. Paint holding the brush as far back on the handle as you can.

7. Paint left-handed if your are right-handed or vice versa.

8. Paint your watercolor pieces with the paper vertical or on a sharp angle, to encourage paint movement.

9. Keep the paper moist; this will keep edges soft.

10. Think about keeping your painting hand relaxed. Tight-fingered brushstrokes are a sign of tension, perhaps even fear. Ed Whitney used to say, "Check your jaw!" If you have tight jaw muscles you will probably lose your free arm and body rhythms and your work will suffer.

SUMMARY

My best results from open-flow painting have been obtained when:

1. Values in the underpainting are not darker than light middle tones (around 4 on a scale of 1 to 10, with 10 being black).

2. There are a few small dry white areas left in locations where centers of interest might be.

3. Nonstaining colors are used, which are easier to lift later, if needed.

4. Plenty of liquid color is available (sometimes in small cups). Speed is essential, or the wet

areas will dry and there will be no color mixing on the page.

5. The page is tilted to create color movement and mixing of the colors, but the mixing is not overdone to produce muddy color.

6. Liquid color is continually fed at the top of the page and other areas of the paper with the large brush until I arrive at a pleasing underpainting.

7. I sometimes use a 2-inch (5 cm) brush to prewet the paper with clear water, leaving random dry areas around which the liquid color flows. The areas left dry should vary in size, shape, and direction and should be left in locations where centers of interest might be. When you prewet the paper with clear water, leaving random dry areas, more blending and mixing takes place on the sheet than if you begin the underpainting on completely dry paper.

8. I gently touch the overloaded brush to the wet paper at the top and other areas, letting gravity do the rest. I seldom brush the sheet, which can cause dulling or overmixing of the color.

9. There is noticeable dominance of color temperature—either dominantly warm or dominantly cool.

DEMONSTRATION: A STILL LIFE

I must say that I don't work differently on still life subjects from landscape or figurative paintings. Starting with the idea or concept, I always go through a study of small 3 × 4" (8 × 10 cm) value drawings—not detailed at all, just major shapes and value locations. You can do these very rapidly and I always try to have more than one to choose from.

I love flowers and I especially enjoy raising bearded iris. When they begin to bloom, I can't resist trying to capture their wonderful shapes, colors, and textures.

Here is a design drawing of two irises from my garden, enlarged to full sheet size.

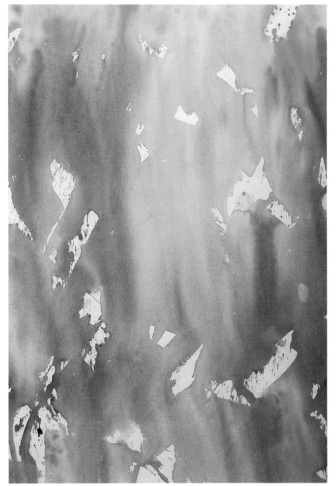

I chose this open-flow underpainting from my inventory because its colors complemented those of the blossoms.

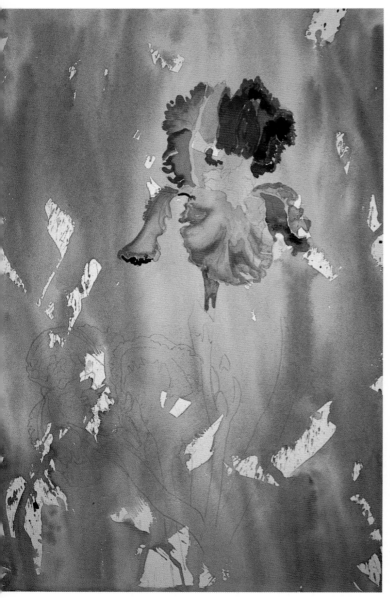

Next I transferred my drawing onto the underpainting, using a light box. I then began to model the images, starting with the top flower.

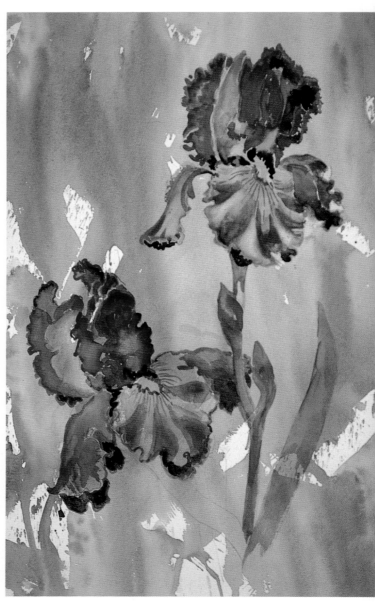

By this point, both irises were fairly well painted in, as well as a stem and one of the bladelike leaves.

I continued refining the shapes until I liked the overall design and colors. Finally I made minor adjustments in values and colors to complete the piece.

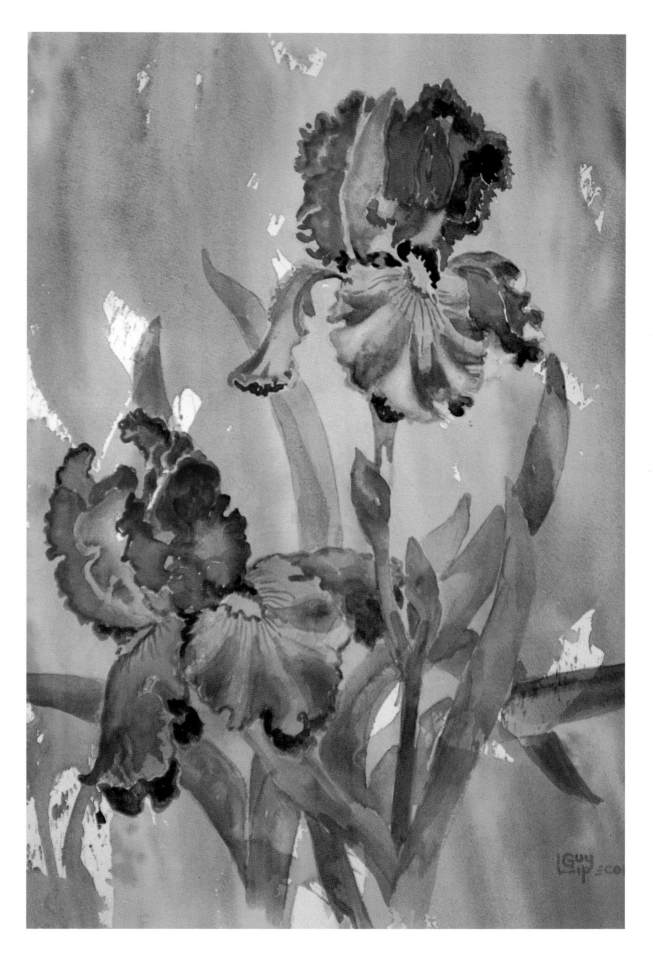

Open-Flow Landscapes

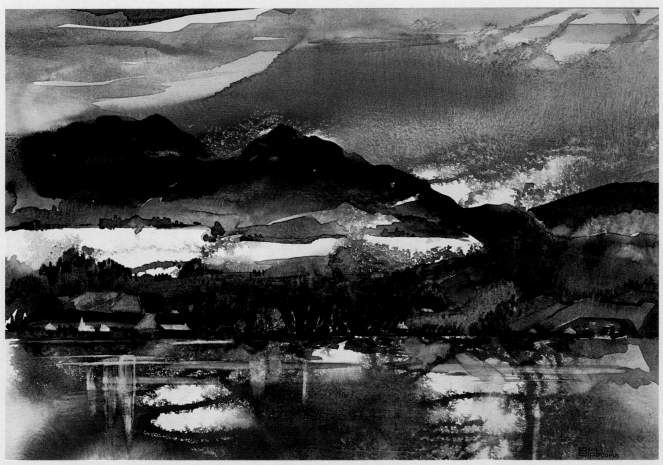

RED SAILS. Watercolor on Arches 140 lb. cold-pressed paper, 22 × 30″ (56 × 76 cm). Private collection.

> *"Only after years of painting outdoors should you try to paint out of your head. Without that experience, you will lack the necessary inventory of knowledge and forms derived from nature, and any of your efforts will lack conviction."*
>
> —Edward Betts

The great advantage of painting on location is the emotional energy you get from working out in the open, in nature. Many watercolorists start painting because they love nature and want to capture its beauty. Being right out there in the middle of it can bring a wonderful emotional high that often yields unexpected results.

However, many beginning artists try too hard to reproduce exactly what they see. The most difficult task for the landscape painter is the elimination process: deciding what to leave out. Your main goal is a strong design, not a meticulous reproduction.

Why duplicate something you can photograph? Where the artist is concerned, duplicating nature is not necessarily a worthy goal. Rather, *interpret* nature from your unique viewpoint, using your unique vision of shapes and colors. This is what will bring strength and life to your paintings. Present a personal viewpoint of your landscape or seascape using exaggeration, new color chords, and any other variety of methods to raise the viewer's interest. Reach in all directions.

Once you get excited about on-site subject matter, it's wise to plan the response of your viewer. Where will the viewer's eyes enter your painting, and along what paths will they travel? Plan this by designing value paths, shapes, line movements, and color selections. This process applies to most paintings, not just landscapes. When the viewer really has an emotional involvement, the painting has probably succeeded.

THE PROCESS OF PAINTING ON LOCATION

I approach painting on location in a number of ways, depending on the mood I want to capture and the time I have to work at the location (sometimes dictated by the weather!). Anytime I am outside, I try to work rapidly—attacking the page. I establish the major shapes in a hurry because the rapidly changing light may cause me to lose whatever shapes attracted me.

If I have a number of open-flow underpaintings in inventory, I may take half a dozen with me to the site and design my landscape directly on an underpainting, doing the finished painting right there on the spot. (I may touch up a few details in my studio later.)

If my time is limited for any reason, I prefer to make rapid three-value (white, gray, black) 2 × 3" (5 × 8 cm) thumbnail designs, placing the major

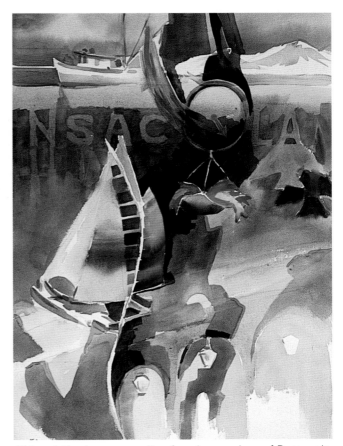

This painting is a composite of my impressions of Pensacola, Florida. It contains many local features of the community, which were worked into a design ahead of the painting process. I did this piece as a demonstration for the annual meeting of the Southern Watercolor Society some years ago.

shapes and values quickly. Later in my studio I will use the grid system to enlarge the best thumbnail design, and then I transfer it onto a suitable underpainting. Photographs are very helpful as back-up material: one with the whole scene in focus, one that focuses as closely as possible on the most exciting shapes and textures that attracted me in the first place, and one of foreground material.

It is not necessary to limit yourself to what you can actually see from your viewpoint on location. It's fun to build a composite of your impressions of the area, taking characteristic elements of the environment. Design from these and tell a bigger story.

The painting process outlined below really applies to most kinds of painting and other creative endeavors. It's a process of give-and-take between the conscious and subconscious parts of the artist's mind. In more experienced painters it takes place more quickly and spontaneously than in beginners, who must focus more clearly on each individual step:

Prepare. Understand your subject, look hard, see. The more information you have about your material, the better your chance of finding a good solution. (This step is a left-brain task.)

Incubate. Turn off the analytical conscious left side and let the intuitive subconscious, or right brain, work.

Reach a breakthrough. Eventually you will feel a flash of insight or guidance, a sense of inspiration as if a light is turning on in your mind. (This is the right brain in action.)

Verify. Refine the idea or concept. Consciously develop the design, values, and colors. (This is a job for the deliberate, logical left brain.)

Make an emotional statement. Don't just paint reality; make your painting express your unique feelings about the subject.

SUGGESTING NATURE'S TEXTURES
Landscapes are the least regimented, most free-wheeling type of representational painting. Skies can contain almost any shapes; so can land masses. This gives landscape painters much freedom to interpret their subject. Shapes that add nothing to the work can simply be eliminated, while other shapes and objects can be added to create interest, balance, excitement, harmony, conflict, and unity. A well-designed and exciting underpainting is often just what is needed to turn a not-too-interesting landscape into an eye-stopper.

Watercolorists also have many options for representing textures. For example, scrape-outs to represent grasses, trees, shrubs, and so on are often more effective than using masking methods because scraped-out edges can be soft and the appliquéd look is avoided.

Since trees are a love of mine, I'm including examples of six different ways to treat tree surfaces. Note that none of these look photographically accurate, but all are interesting to look at, and all convey a clear impression of the tree trunk to the viewer.

TIPS

- You can scrape a texture out of wet watercolor with the edge of a pen knife or wedge handle. With flat stiff brushes, you can push the paint aside while the area is still wet and bring back the light areas. You must do the scraping quickly before the color settles too deeply into the page.

- The same technique may be used to make darker areas. By scraping when the area is very wet—and therefore breaking the sizing and surface of many papers—you can get more color to go into the damaged areas, thus creating a darker surface.

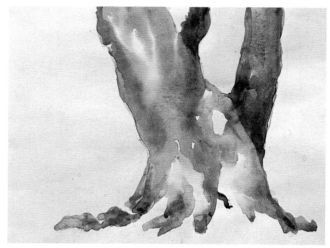

The painted areas were first wet with clear water. Color was then touched into them, and the piece was tilted to make the color move. This produced mostly soft edges throughout.

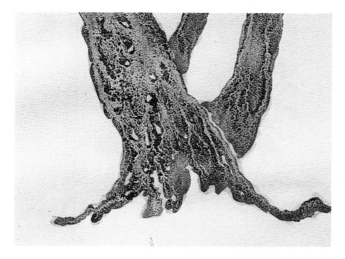

This trunk was painted using a mixture of two pigments: Rembrandt brown oxide and Winsor & Newton viridian, mixed in equal amounts and diluted with water to a consistency that would flow. The paint was applied from the top on a sloping surface. The oxide tends to separate, mottling brown with pale green. When it works well, this effect simulates the bark of old live oaks very well. Rembrandt red oxide works also, but this technique is not always reliable, and it does not seem to work with other brands of these colors. Do keep in mind that you have to leave open areas so that you can add touches of other hues later, after the piece dries, and keep them clean and bright.

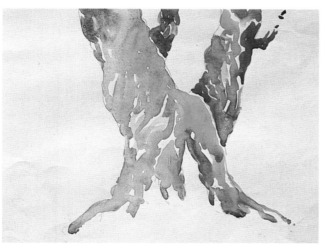

Working on dry paper, I began to paint at the top of a sloping surface and gradually changed colors as I came down through the trunk of the tree, producing moving color and some hard edges.

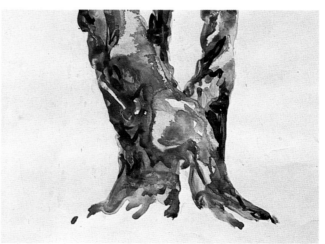

This time I worked on dry paper and painted yellow ochre, Vandyke brown, and raw sienna rapidly over the entire trunk. Quickly, while it was still wet, I used a dull knife blade and pushed the color around to suggest light striking the tree in various places. After this had dried, I added touches of cerulean blue.

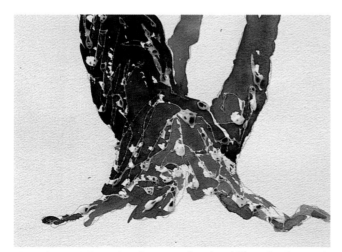

On this trunk I used a dispenser bottle of Elmer's glue and designed bark rhythms with the lines of glue. After allowing it to dry overnight, I painted over the glue, which acted as a resist and retained light lines throughout the trunk.

In this example I used partially overlapping layers of color, waiting for each color to dry before adding the next. I painted barklike shapes first in yellow ochre, then in Vandyke brown, and added finally a few touches of cobalt blue. The overlapping colors created a number of new tints and tones.

DEMONSTRATION: A LANDSCAPE

Here you see an on-location landscape painting being developed. I try to take three or four open-flow underpaintings with me when I go outside to paint. This almost guarantees that my landscape will have variety and interest, not just a too-perfect, photographic look.

I was attracted to this live oak tree, about two hundred fifty years old, on the Carolina coast; I decided to play its massive strength against the elevated white cottage. After making a number of small value drawings, I finally chose this one and used the grid method to enlarge it to the size of half a sheet of index stock: 15 × 22" (38 × 56 cm).

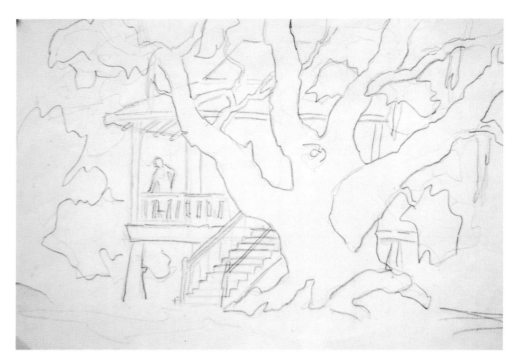

Next I decided on an underpainting containing a dominance of earth tones and used the light box to transfer the drawing to the underpainting. I began to darken areas to pull out the roof line of the cottage. Using a soft brush, clean water, and facial tissues, I lifted most of the color from the open-flow underpainting in the roof area, the porch rail, and the corner post under the porch.

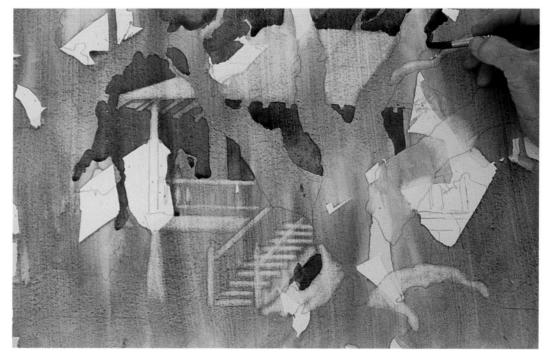

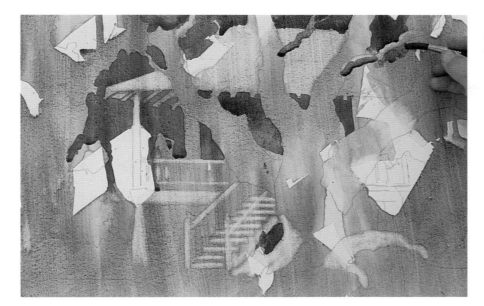

I started to exaggerate moving color on the massive limb structure of the oak.

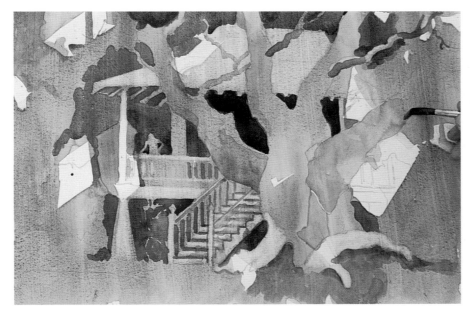

I did some lifting of color on the porch supports and banisters, and I painted their shadow areas as well as those under the porch. Next I defined the oak's arching roots so characteristic of these great trees. One of the underpainting's original white areas was painted through when I defined the big limb on the right.

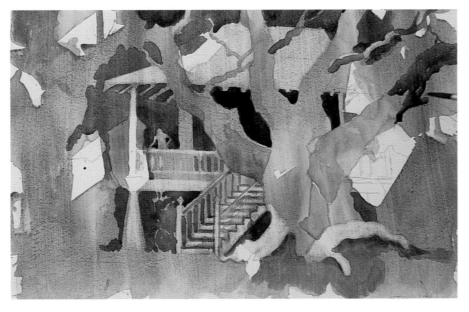

Next I separated the forward limb from the trunk by darkening it in value; you can see the effect of this more clearly in the next step.

Cool blues, greens, and violets were introduced into some of the white unpainted areas to cool down an otherwise warm painting. Still there are some oddly placed, oddly shaped lights that didn't bother me, so I left them for the viewer to wonder about. I also defined the ground in front of the house by lifting an area where the light strikes it.

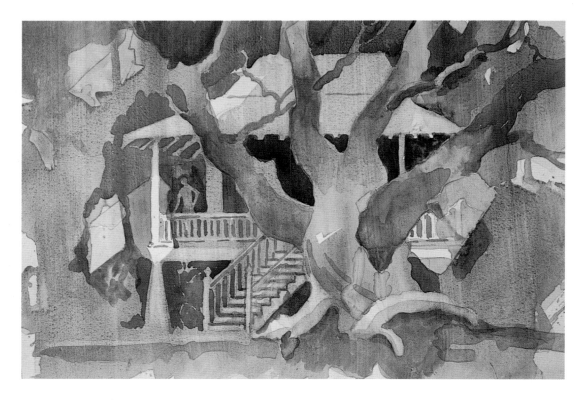

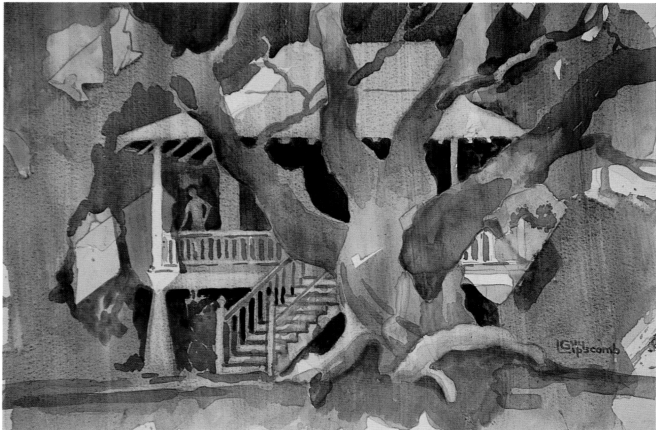

ANCIENT AGE. Watercolor on Arches 140 lb. cold-pressed paper, 15 × 22" (38 × 56 cm). Collection of the artist.

To finish the piece, all I had to do was clean up a few edges and adjust a few disturbing values. The finished piece has a freshness often lacking in on-location painting.

FINISHED OPEN-FLOW LANDSCAPES

Here are finished landscapes that employ the open-flow technique. Some were painted on location using previously completed underpaintings. Others were done in the studio using drawings done on location.

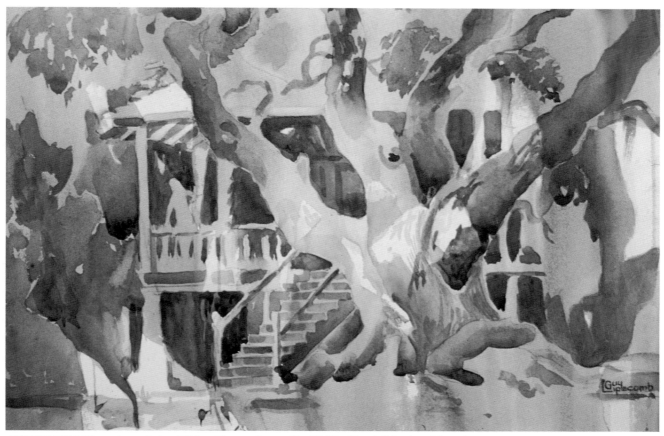

ANCIENT AGE II. Watercolor on Arches 140 lb. cold-pressed paper, 15 × 22" (38 × 56 cm). Collection of the artist.

Here is the same design with a different underpainting. Notice how I changed hue on the tree limb when the underpainting changed color. I reserved all the whites until I had done all I could in the painted areas. Then I carefully began to eliminate the whites that were fracturing the painting, using either colors found around the whites or neutrals.

RACING THE STORM. Watercolor on Arches 140 lb. cold-pressed paper, 22 × 30" (56 × 76 cm). Private collection.

This underpainting was done on a dry, gesso-coated board, and the lower half reminded me of the khaki sea on the Atlantic coast on a gray day. I lifted highlights on the dinghy. My goal was to paint a sailboat picture that didn't look like any I had ever seen. I think I succeeded— though I had trouble with the figures, not having models!

MEETING HOUSE I. Watercolor on Strathmore hot-pressed illustration board, 30 × 40" (76 × 102 cm). Collection of Mrs. Henry Foster.

I was attracted to this lovely subject, initially because of the interesting bounced light under the archway and the patterns formed by the shadows. The combination of curves is balanced by the verticals and horizontals of the architecture. I chose a blue dominance to relieve the dull neutral of the local color, and I lifted out a few places on the archway and the columns above.

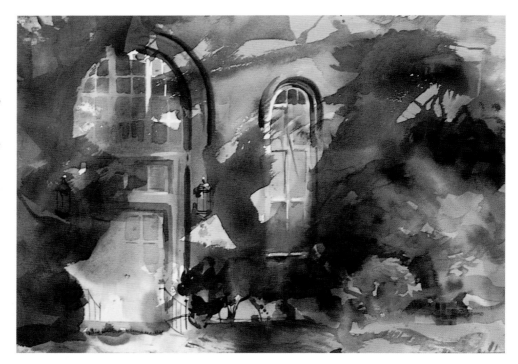

SUNDAY SHADOWS. Watercolor on Arches 140 lb. cold-pressed paper, 22 × 30" (56 × 76 cm). Private collection.

I was painting with a group outside Charlotte, North Carolina, and the rest of the painters had picked other subjects. I had with me an underpainting with luminous dark shapes in it, and I realized that I could use the dark shapes as shadows on the front of the little rural church ignored by the group. There were actually no shadows on the building and no tree to cast them; I used the shadows as they were and painted the church front behind them.

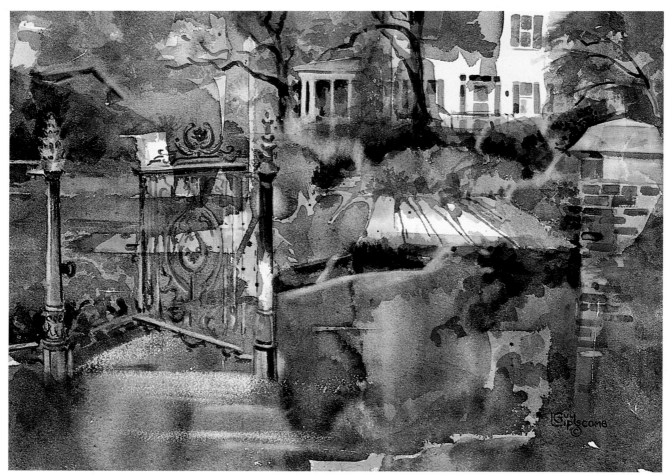

KEEPING UP WITH THE JONESES. Watercolor on Arches 140 lb. cold-pressed paper, 15 × 22" (38 × 56 cm). Private collection.

This open-flow underpainting was done on location, and it took only a few minutes to dry because it was tilted. I liked some of the interesting shapes in the middle ground and decided to preserve them, still not knowing what they represented. Then I added the iron gate and brick post and lifted out color to lighten part of the white house in the background. All this was done in one session on location with very little change to the original underpainting.

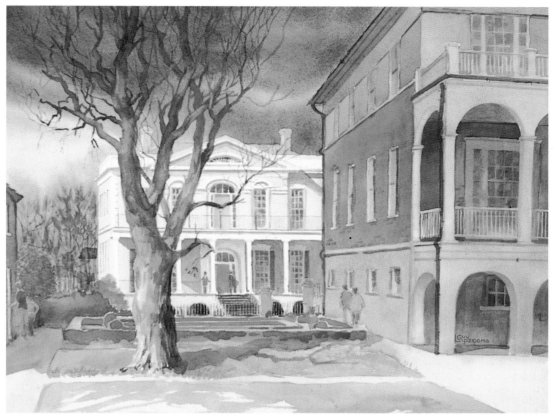

OLD SOUTH I. Watercolor on Arches 140 lb. cold-pressed paper, 22 × 30" (56 × 76 cm). Collection of South Carolina National Bank.

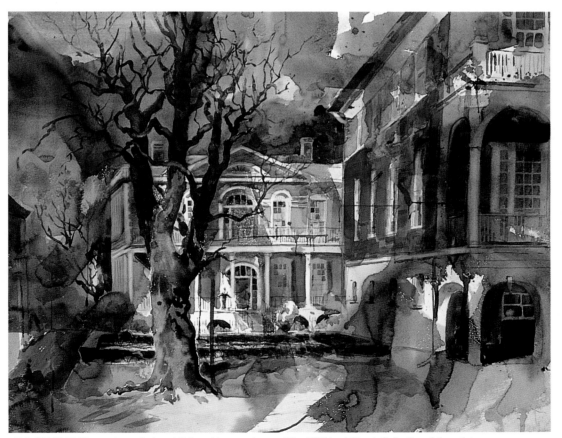

OLD SOUTH II. Watercolor on Arches 140 lb. cold-pressed paper, 36 × 46" (91 × 117 cm). Collection of the artist.

This piece has led a double life. I made a design drawing incorporating two historic buildings in my hometown, and painted in a conventional way. The result was Old South I, a reasonably well done but "ho hum" painting that excited nobody.

The following year for the same competition, I pulled out my old design drawing of the buildings and went for a bold dramatic open-flow underpainting with an intriguing color chord. Old South II not only won the competition, but went on to win best of show in a national competition later.

These two paintings seen together illustrate exactly what the open-flow method is all about, and what it can do to enliven a painting.

Open-Flow People Paintings: Figures and Portraits

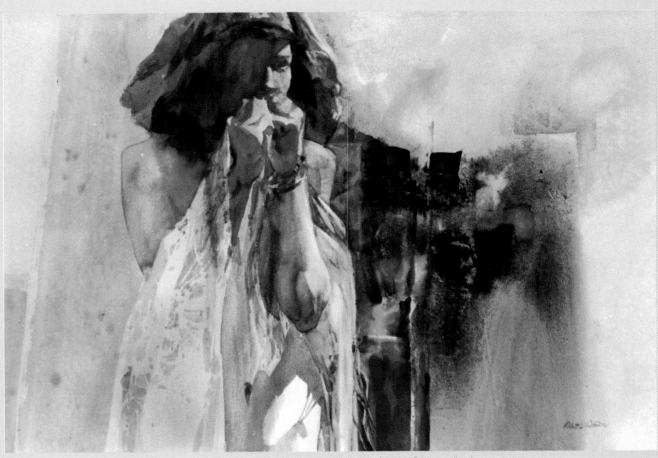

MAE by Robert E. Wood. Watercolor on Arches 140 lb. cold-pressed paper, 22 × 30″ (56 × 76 cm). Private collection.

> *"Three to four years of figure drawing will do wonders for your drawing."*
> —Rex Brandt

The open-flow method adds interest, movement, and variety to images of people. Why paint people? (1) They are interesting subjects. (2) They lend scale to your work. (3) They give life to paintings. (4) They tell stories and express feelings and attitudes. (5) They show and express emotions. For all these reasons, it pays to design people into your work.

People like to look at people! The next time you go to a great museum, notice what a high percentage of the paintings are built around images of people. In recent years, I have become much more interested in using the human form as the major focus in my designs. I do some commissioned portraits, but mostly character studies and people doing things alone or in groups.

If you are saying to yourself, "But I don't know how to draw people!" you are not alone. This can be remedied, however.

PRACTICE YOUR FIGURE DRAWING SKILLS

Begin to draw every single day. Join a life drawing class or an anatomy class, and get out your many books on life drawing that have been gathering dust. Draw whenever you can observe people doing something. Models are not in short supply. They are all around you every day: your family, passers-by, people in airports or bus stations, even your own reflection in the mirror.

One good way to practice your drawing skills is to draw while watching television. The people on the screen won't pose for you, that's for sure, so you really have to look hard, try to freeze a pose or gesture in your mind, and then remember it as best you can. Zero in first on the big shapes, then each one of the shapes that decorates the big shapes. It's memory drawing to some extent, but you will be surprised how fast you will record the essence of your subjects.

Talk shows and concerts are my favorites for drawing practice because I get more than one crack at my subjects. I love to listen to classical music, and I have many drawings of the orchestra conductors and the musicians in the front row. Great fun, great practice, and at the right price!

As I wrote this, I looked up and saw an aerobic exercise program on the television. I jumped at the opportunity to draw the human forms in exercise positions. What a marvelous source of models!

If you are interested in didactic or story-telling pictures, you have to be careful not to get so wrapped up in the message of the picture that you neglect the design and the paint quality of your work. This results in another "ho hum" painting. There's not a thing wrong with a story painting, but in order to have impact, it must be done in a unique and exciting way. An open-flow underpainting may help you.

We have already mentioned the importance of keeping a notebook with you at all times. This will help you develop your drawing skills in general and your figure drawing skills in particular. Draw people in everyday situations—working, resting, and eating. They need not be in detail, just gestural forms and shapes. Forget details in this type of practice; work for rhythms, balance, and scale. You will soon find that you have improved your understanding of the human form.

My good friend Serge Hollerbach, a fine New York painter and teacher, readily admits that he is a sketch addict. He's really in love with pencil and paper. It's his favorite pastime and a vital part of his art activities. He often exaggerates to make a point, but his figures are believable. They show life without glamour and make-believe. Study his economy of line and gesture in the sketches shown here.

These pen-and-ink sketches done on location by
Serge Hollerbach of New York are fine examples
of seeing with the painter's eye. Each has life,
believable exaggeration, and a charm all its own.
(Courtesy of Newman & Saunders Galleries.)

SEATED FIGURES

Serge Hollerbach has given me permission to use these next few pages of drawings with his comments to explain how expressive drawing was taught to him in Europe during his developing years. I think the method is indeed sound and is built around an understanding and use of straight lines, proper angles, and critical distances and relationships between points. I recommend that you try this method and see if it doesn't make your drawings more interesting and alive.

Straight lines are actually much more expressive than curved lines. In fact, every curved line can be broken down into several straight lines. By working this way, you can get the character of any particular curve. So do curved backs of people sitting, drawing their arms, legs, and heads with a succession of shorter or longer straight lines.

Make simple drawings from life of sitting figures, using shorter and longer straight lines. Most important, stay with these exercises for a while. Consider them similar to calligraphic exercises for making a good letter by repeating it dozens of times. Don't show them to anyone; they are your practice pages.

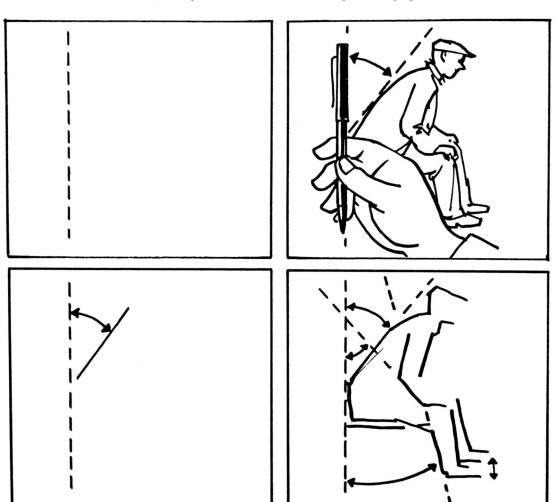

To draw the curved back of a seated figure, start with a vertical straight line. Use your pen to help you measure the angle between the vertical and the straight line that expresses the predominant line of the back. Then measure other angles in relation to that. (All the drawings on pages 57 through 59 are by Serge Hollerbach.)

We are easily able to judge differences in length if two lines, one short, the other long, are shown to us one next to the other. In life their placement is more complex, and we get confused very easily. Make it your habit to compare sets of them: a with b and c, then d with e, then abc with d and e, and so on.

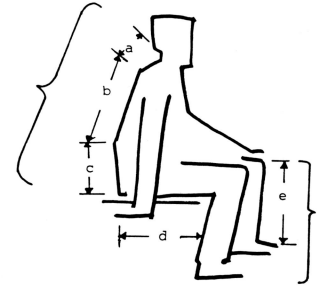

Simple drawings like these are excellent practice. Draw sitting figures from life, using shorter and longer straight lines.

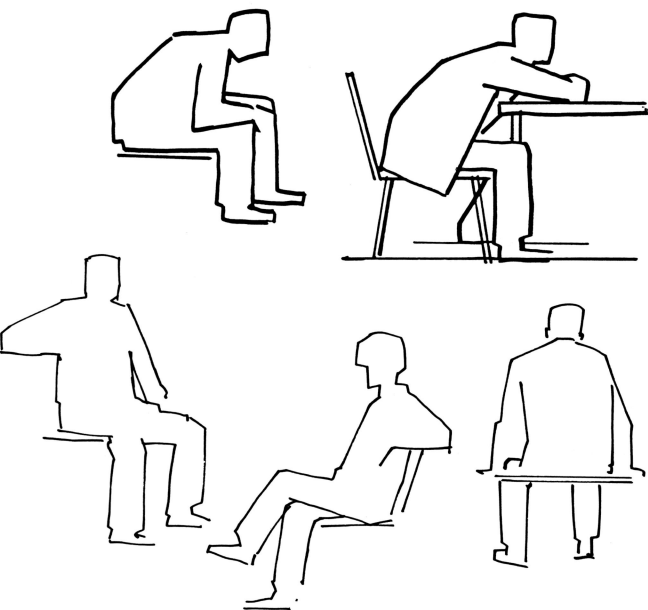

STANDING FIGURES

Having made yourself more or less familiar with sitting figures, try standing ones. Again, draw a vertical line lightly, and then mark top, middle, and bottom. (Waistline is roughly in the middle but will vary slightly depending on the proportions of that particular person.) There are three basic positions in which a person stands: weight on both legs, weight on left leg, and weight on right leg. Holding your pen vertically, see the angle of torso and legs.

Balance is important in drawing the human form, as is rhythm in body movements. There are eight important points in a human body that you have to check when sketching standing figures. They are: two shoulder points, two top points of pelvis, two points where the thigh bones are attached to pelvis, and two knee points. By holding your pen horizontally, see which way the shoulders lean in each case and how the four points of the pelvis and two knee points shift in the opposite direction. The weight is predominantly on the one foot directly under the head. Some people are less flexible than others so that these tilts are difficult to see. But remember, the body always works this way, and you are safe in following or even slightly exaggerating these tilts.

Here you see a standing figure with weight on both feet and then on one at a time. Note the position of the waist.

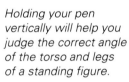

Holding your pen vertically will help you judge the correct angle of the torso and legs of a standing figure.

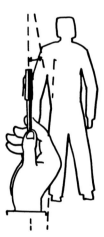
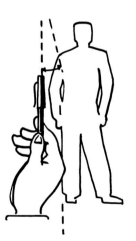
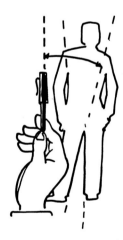

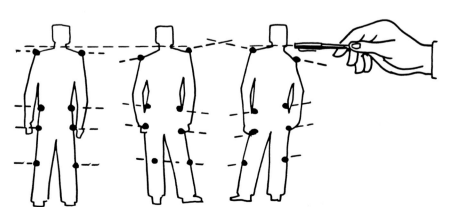

Left: *If the person is standing straight, all eight points of reference will form horizontal lines.* Center: *If the shoulders are tilted, the other six reference points are always tilted parallel in the opposite direction. Here the right shoulder is higher, so the right pelvis and knee points are lower.* Right: *Conversely, if the left shoulder is higher, the left pelvis and knee points are lower.*

PORTRAITS AND CHARACTER STUDIES

Painting figures in action will give you much of the artistic adeptness needed for painting portraits and character studies—except that portraits require you to please the customer, not yourself. Most painters find this difficult. You are painting to enhance, not always painting what you see—and maintaining a good relationship with your client is crucial if you are to succeed as a portrait artist. The best portrait painters are able to capture the sitter's characteristic expression and a glimpse of personality, not just the outer contour of the face.

Figures in landscapes, airports, on the streets or in cafes don't have to please anybody but you. It's great fun to analyze what all these strangers are thinking, what they do, and how they relate to one another. Often dress, gait, posture, body language, and facial expression will tell a lot about the subject, and capturing such things will make a figure study that much more convincing.

I find it great entertainment to record people and places as I travel and constantly add to my vocabulary of gestures and forms for future recall and use. It's a habit-forming activity. When I have time, I like to illustrate letters to family and friends; this is another way to practice and share at the same time. I include a number of quick sketches, gesture drawings, and watercolor sketches to illustrate some of my thoughts. Begin your collection if you haven't already.

Drawing stick figures will help with getting rhythms and shapes in the right size and place. Add volume to the stick figure before you put on the clothing. It is a good idea to practice painting figures with a good round brush, painting volumes, not outlines. Where the legs and arms change size, just bear down on the round brush to widen the stroke and let up on the pressure to narrow the stroke. With practice you will be surprised how fast you will get the feel of volume painting. If you do these volume figures in yellow ochre or light burnt sienna, you will be able to dress the images right over the pale figures.

Again you must understand the components of the human form in order to be able to paint convincing figures in your painting. Portrait and life drawing classes will help, as will these exercises:

1. Start by drawing parts. Take every major part of the human form and draw it from at least three angles—front, back, and side view. To learn even more, include views from above and below of a reclining figure. That's five views of the feet, legs, torso, arms, neck, head, hands, eyes, nose, ears, and mouth. Doing 55 drawings should keep you busy for a while, and you will know a lot more about the human form.

2. Put emotion in your work. Facial expressions add to your ability to communicate. Draw emotional faces expressing sorrow, joy, surprise, hunger, fear, anger, and whatever other emotions occur to you.

3. Draw yourself from every angle—your head, hands, feet, and torso. There is no better way to understand the human form. I have rigged up a folding mirror in my studio that allows me to draw myself from almost any angle. Some bathroom mirrors are built this way and have mirrors on both sides for even more views.

TIP

- To capture characteristic facial expressions, most of which are very fleeting, try to engage your subject in topics that deeply interest him or her. I like to keep my camera clicking while such conversations are going on, hoping for characteristic subtle expressions that express the subject's unique personality. So many portraits are dull, deadpan attempts.

I painted these gestural poses of people, which are simplified symbols of the human form. Practice doing these with your brush.

PIAZZA PATTERNS by Jeanne Dobie. Watercolor on Arches 140 lb. cold-pressed paper, 20 × 29" (51 × 74 cm). Collection of the artist.

This is a fine example of a strong, simple design decorated interestingly in the transition area between the major light shape and the dark shape. The overlapping forms add depth and scale.

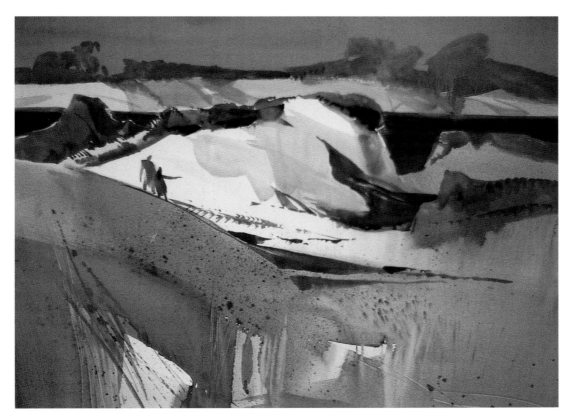

PENSACOLA DUNES by Robert E. Wood. Watercolor on Arches 140 lb. cold-pressed paper, 22 × 30" (56 × 76 cm). Private collection.

The massive rhythmical shapes of these Pensacola dunes are exaggerated to create drama in this interesting on-site painting demonstration. Well-designed interior light areas contribute to the success of this piece, and human forms give scale.

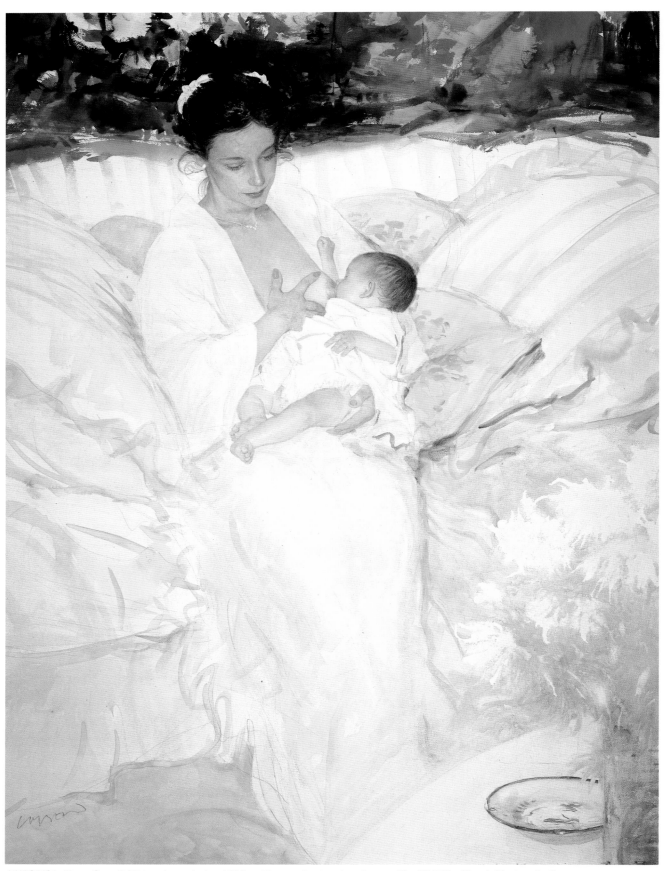

NURSING by Henry Casselli. Watercolor on Arches 140 lb. cold-pressed watercolor roll paper, 52 × 39" (132 × 99 cm). Private collection.

This Madonna scene is a fine example of a well-designed, very expressive human relationship, done in a masterful way. Human figures dominate with universal appeal.

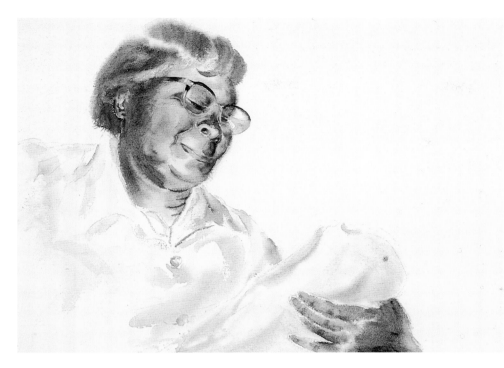

LULA MADONNA. Watercolor on Arches 140 lb. cold-pressed paper, 22 × 30" (56 × 76 cm). Collection of the artist.

Lula was the mother of twelve children, and she had helped us for years with our four daughters. She had such a wonderful face and personality that I wanted to capture her in paint. I took one of my girls' dolls, put it in Lula's arms, and said, "Lula, I want you to think about your favorite grandchild!" (Her current favorite was always the youngest one.) I caught her maternal happy expression on film, and cherished the remainder of the moment.

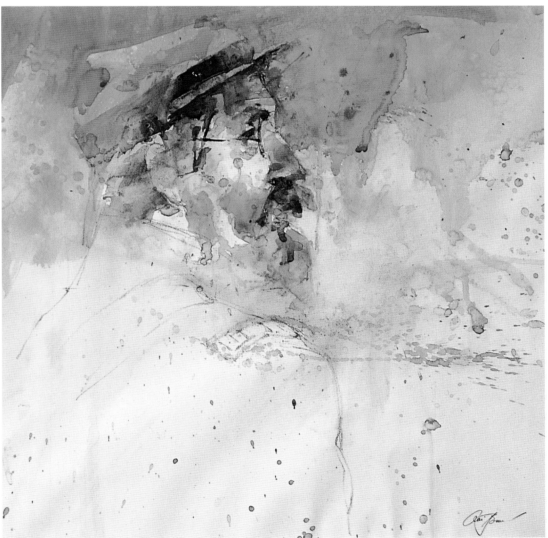

SOLDIER STUDY I by Alex Powers. Watercolor on Arches 140 lb. cold-pressed paper, 17 × 17" (43 × 43 cm). Collection of Guy Lipscomb.

Alex Powers is a very direct, brave painter. This is a fine example of his loose, textural approach to painting the human head. Notice the good variety of edges both inside and out. He has captured both character and a degree of mystery: Much is left unsaid.

DEMONSTRATION: A PORTRAIT

Too often character studies, portraits, and paintings of people become take-offs, even copies of photographic images. Such paintings are often so factual that they are dull and uninteresting. There is always a great temptation to show too much in this type of painting. The open-flow approach is one way to break that temptation and present people in a new light and still not distort too much. The demonstration that follows is a character study from a series of candid photographs of a friend and fellow painter, but there is no feeling of camera imitation. That factor gives it a feeling of surprise and interest that is seldom found in people paintings.

Here is the original drawing for the character study. My friend Wyman Trotti was an ideal subject. A lifelong friend with an infectious laugh, he was in great demand as a model in art classes. I used a candid photograph for reference.

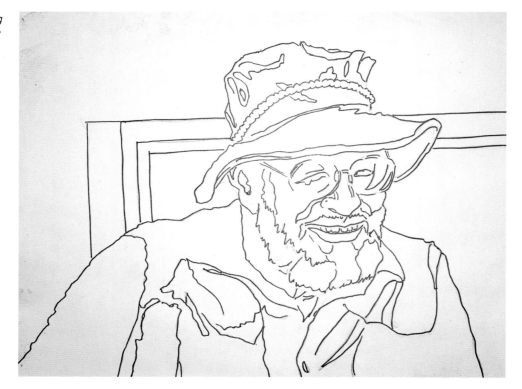

I chose this open-flow underpainting to go with it. The colors were right to convey the jovial portrait I wanted. A dark or cold background would never have worked.

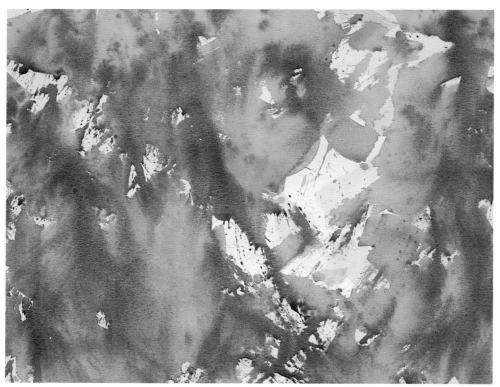

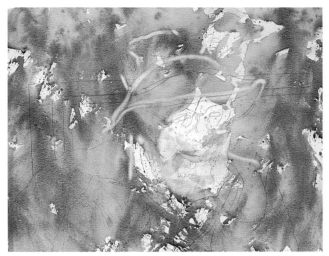

I started by lifting some color in places where there would be whites or near whites—that is, where surfaces would be reflecting the sunlight. The edges of the hat and light areas on the face were lightened by lifting out color with a soft, wet sponge.

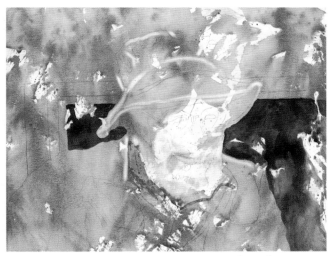

Next I established the darkest background for reference, using darker values of colors already on the sheet.

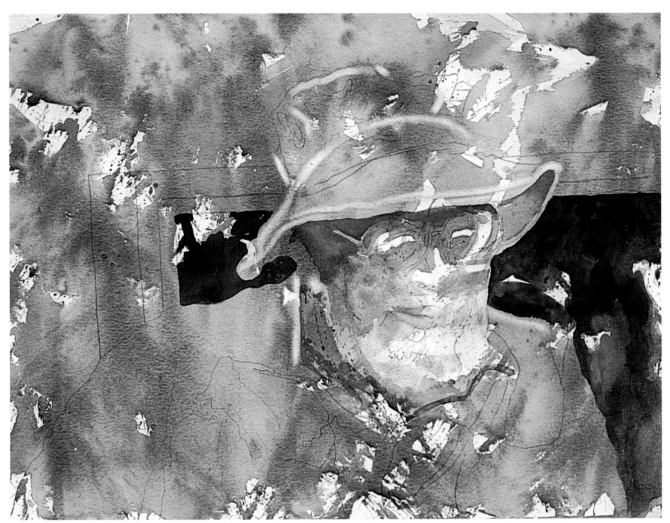

I began modeling the face, working mainly in the shadow areas because most of the face was already in light middle tone. In order to put more life into the expression, I begin to modify existing hues in the hot zone of the face (the band across from ear to cheek to nose to cheek) with a few changes in hue around the mouth.

I continued modeling the head, hat, and clothing, using mostly tones of pigments already existing on the page. I completed the figure and worked on the background underpainting. It needed a change of value in some places, and a few whites needed to be painted out because they fractured the unity of the piece.

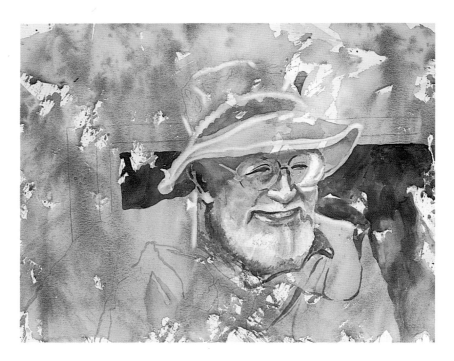

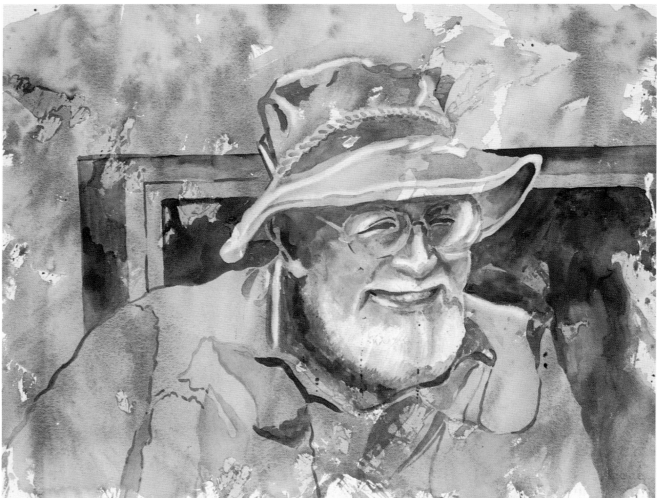

CAPTAIN WYMAN. Watercolor on Arches 140 lb. cold-pressed paper, 22 × 30" (56 × 76 cm). Collection of Wyman Trotti.

This final stage of the painting included adjusting the values in the shadow and background areas (which were too light) and cleaning up edges of shapes that were poorly painted. The finished portrait captures his larger-than-life friendliness and love of people.

FINISHED OPEN-FLOW PEOPLE PAINTINGS

People are a major interest for most of us, beginning with family, friends, heroes, and just people in general. The never-ending variety and unpredictability of humans make them tremendously interesting subject matter for the painter. Yet most new painters are intimidated by painting people and choose other subjects for their work: landscapes, still lifes, or florals.

The only solution is to study and practice until you become a better observer and can draw the human figure accurately.

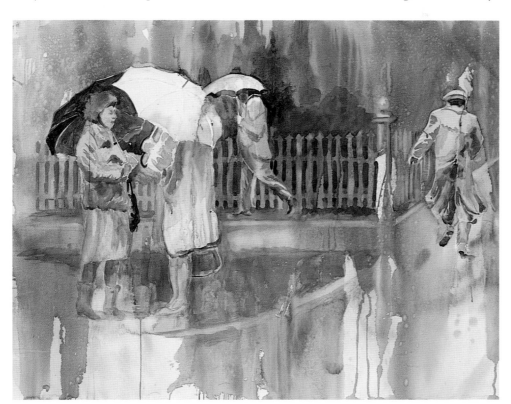

WET GOSSIP. Watercolor on Arches 140 lb. cold-pressed paper, 36 × 46" (91 × 112 cm). Collection of Richland Memorial Hospital.

This underpainting suggested a rainy, cool day. Searching my archive of images, I found newspaper clippings 15 years old of rainy-day people. With the underpainting in front of me, I began to design the picture using images from different sources. Most of the underpainting was left untouched, but I did lift color on the light umbrellas, and I painted behind the picket fence.

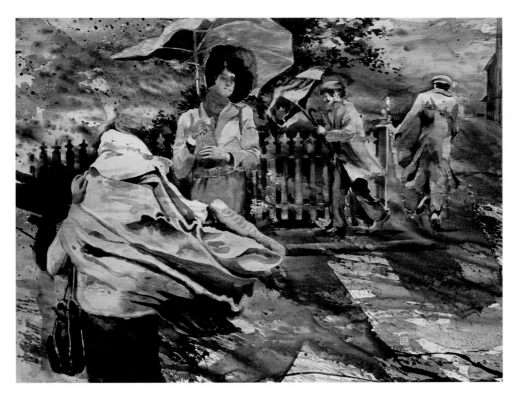

WINDS OF MARCH. Watercolor on Arches 140 lb. cold-pressed paper, 30 × 40" (76 × 102 cm). Private collection.

This underpainting was painted with what is now the left side at the top, and the paint moved rapidly by gravity. Turning it 90 degrees reminded me of a windy, rainy February day in South Carolina, and I went to my references for images suitable for this scene. You could never get models to pose for a painting like this. They all came from candid photographs of people in distress, mostly from storm reports in news accounts collected over the years. You never know when this type of candid material will be useful.

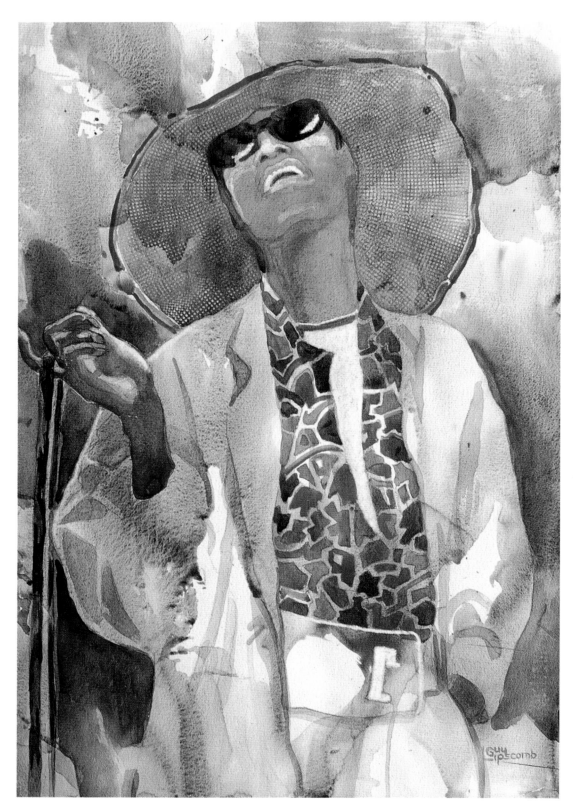

HAPPY DAYS II.
Watercolor on Arches
140 lb. cold-pressed
paper, 30 × 22"
(76 × 56 cm).
Collection of the
artist.

*This piece was
inspired by a
photograph.
The attitude of
the girl's ebullient
hand gesture
attracted me.
After painting
the straw hat in
a solid color
and letting it dry,
I placed an open
plastic screen
over it and used
a cosmetic
sponge to lift
color out. This
process went
slowly, lifting only
a narrow strip
at a time, so that
I could simulate
the rhythms
of woven straw
and avoid a
mechanical look.*

*The portrait
related to the
color chord of the
underpainting
fairly well, but I
did lift color
from the collar
and vest areas
before painting
the vest's
multicolored
pattern.*

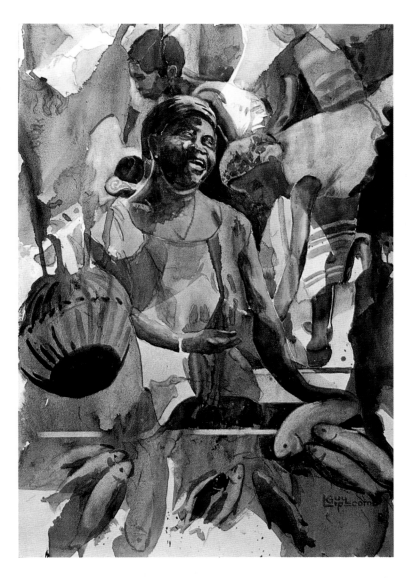

ONLY 99¢/LB. Watercolor on Arches 140 lb. cold-pressed paper, 30 × 22" (76 × 56 cm). Private collection.

This Caribbean market scene was not posed, of course, but since my material had many more people in it, I did a lot of elimination to find a good composition. I was intrigued by the way these shapes fit together and the pattern of the lights and darks.

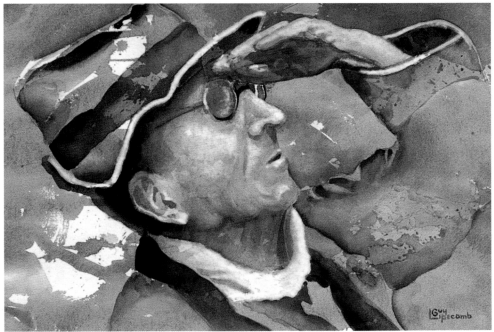

OLD MAN SEEKER. Watercolor on Arches 140 lb. cold-pressed paper, 15 × 20" (38 × 51 cm). Collection of Elizabeth Foster.

In a sense we are all seekers, and I've been working on a long series that I may never finish called "The Seekers." This character study of an old man with his ill-fitting glasses seems to depict the problems of contained curiosity about life despite aging eyes, and in a way his attitude mirrors my own: continuous wonder, study, and hopeful growth.

This underpainting worked well with minimum lifting. There are interesting lights and moving colors on the sleeve and hat.

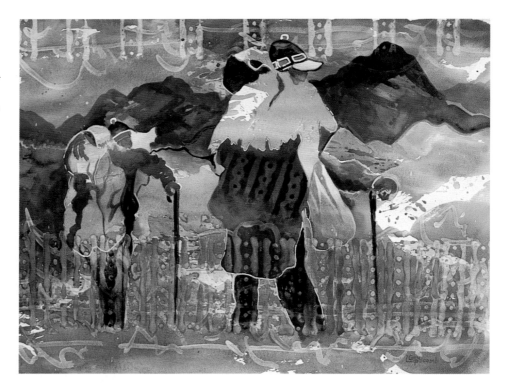

SEEKERS III. Multimedia on Arches 140 lb. cold-pressed paper, 22 × 30" (56 × 76 cm). Collection of the artist.

I have collected a number of wooden stamps once used for printing madras fabrics by hand in India, and I have made some wooden stamps myself. I used two of these to print matte medium onto the paper, and I let it dry before I started the underpainting. Because it does not accept the paint the same way as clean paper, it produces ghost images or textures—in this case, across the top and bottom of the painting. See page 17 for a stamped underpainting similar to the one used here.

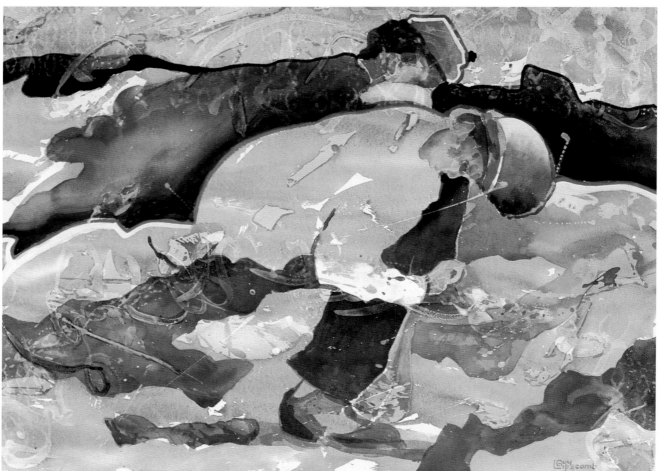

SEEKERS IV. Multimedia on Arches 140 lb. cold-pressed paper, 22 × 30" (56 × 76 cm). Collection of the artist.

This piece also had a coating of matte medium before I did the open-flow underpainting, but it was applied all over the sheet with a 2-inch brush in a swirling pattern for a very different effect.

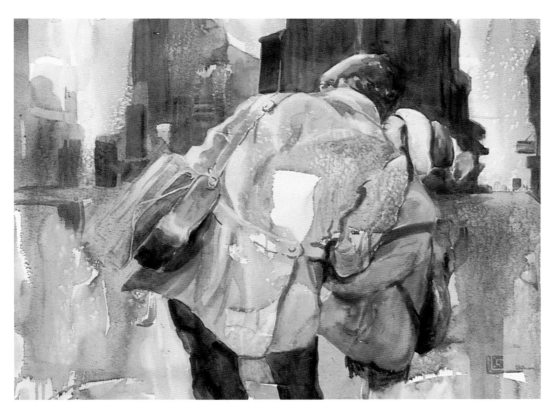

SECRETS. Watercolor on Arches 140 lb. cold-pressed paper, 22 × 30" (56 × 76 cm). Collection of the artist.

There is always intrigue in a whisper! These images were not posed but attracted me quickly. The underpainting had a number of exciting areas that I did not have to destroy to fit in the figures and buildings. Both Secrets *and* Secrets II *have salt stars that reminded me of lovers' feelings. The light shapes on the man's coat are startling, but I liked them and left them alone.*

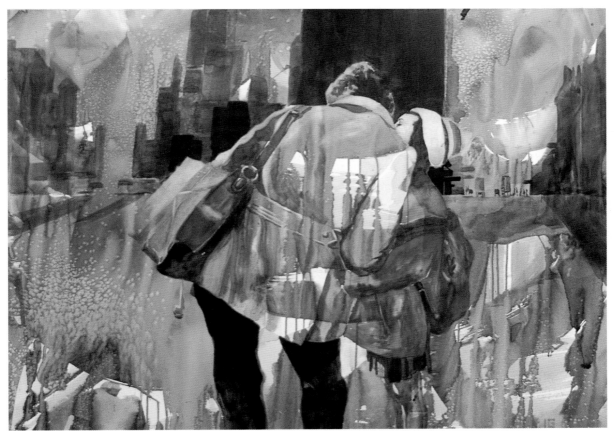

SECRETS II. Watercolor on Strathmore 240 high-surface illustration board, 22 × 30" (56 × 76 cm). Collection of the artist.

I liked Secrets *so much that I thought it might be interesting to try these images on a different working surface and with an entirely different palette of color in the underpainting. Whereas* Secrets *was dominantly violet-brown,* Secrets II *is dominantly green with a lot more pigment movement in the underpainting, creating more intrigue and excitement. This is an example of using similar images but obtaining quite a different result.*

Making Color Decisions

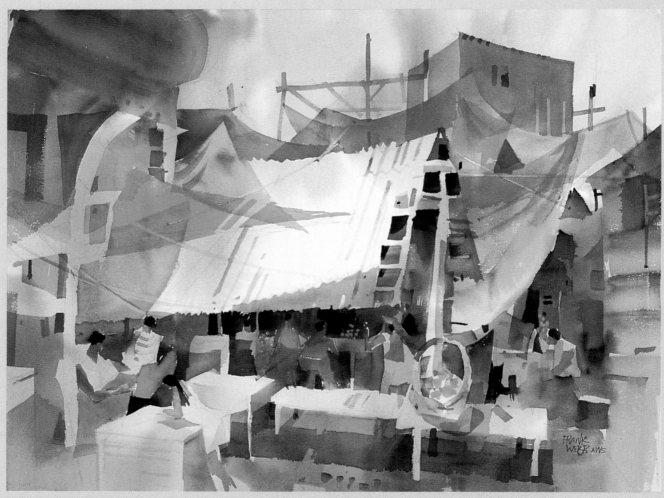

THE MARKET by Frank Webb. Watercolor on Arches 140 lb. cold-pressed paper, 22 × 30″ (56 × 76 cm). Private collection.

> *"To know color, one must experiment, practice, and observe.*
> *Most painters never want to practice with color."*
>
> —Lamar Dodd

Color is one of your most powerful tools. It evokes emotions. It creates excitement, rhythm, and movement. It can overcome values to alter emphasis in your design. Color alone can give movement—a gradation of warm to cool in a wash or a set of shapes. The same principles of color apply in open-flow painting as in all painting. The major advantage of open-flow painting is the variety and unexpected changes of color this method creates. These qualities add excitement and interest to a painting.

So that we are on the same wavelength, here are definitions that I use throughout this book.

Hue refers to where the color is on the spectrum. This is what most people mean when they say "color": red, yellow, green, blue, orange, and so on.

Pigment is the physical substance from which paint is made. It is often named after a chemical, such as cobalt for cobalt blue and cadmium in cadmium red light.

Chroma means the brightness of the color. Chroma can be changed by graying the color with its complement, by adding black, or by diluting with water or white.

Temperature refers to ranges of colors that are generally considered warm (yellow, orange, red) or cool (blue, green, violet). However, temperature is always relative; for example, alizarin crimson is cooler than vermilion or cadmium red light, even though they are all reds. You must decide what the dominant temperature of the painting will be, and then plan the temperature relationships among the colors, whether obvious or subtle.

Value refers to relationships between light and dark, and it is crucial to a painting. It establishes depth, location in space, relationship to the light source, and how objects are separated from each other. It also tells the viewer which objects to focus on as centers of interest.

COLOR SHOULD COME FROM YOU, NOT THE SUBJECT

Local color is often uninteresting or even drab. The open-flow method is particularly useful in helping artists break away from local color; it forces you to think in freer terms.

When you begin a painting, consider the strength of your hues and choose a dominant temperature, warm or cool. You cannot expect good results from a painting that is half warm and half cool, or from one with too many colors. Joseph's coat of many colors may have been all right for Joseph, but too many colors fracture the unity and harmony of a painting.

Pick out a range of analogous colors (side by side on the color wheel) that will make up your dominant range, and then think about the colors (usually across the color wheel) that will make up the foil or accents in the picture. The balance of the picture will usually consist of the warm and cool neutrals, described by Eliot O'Hara as the glue or amalgam that holds the painting together.

There is a difference between dull colors and dirty ones. Dull color can be wonderfully transparent and clean, particularly when played against bright color. Dirty or muddy color usually comes from overmixed earth colors or combinations of sedimentary earth colors and dye colors overmixed. When the dominant colors and the accents are played against the neutrals properly, wonderful results can occur.

EXCITING NEUTRALS

Neutral colors—warm and cool grays with a hint of all the colors on the wheel—become the foundation of many fine paintings. Their gentler tones bring out all the magic whites, luminous darks, and accents of intense color. Many times the largest shapes wind up being neutrals.

Why are warm and cool neutral shapes so important? They provide the background music for the strong value and color chords. They provide translucent atmospheric areas and illusions of space or moisture, and veils of mystery when needed.

Grays are very important elements in a color scheme. They move in subtle ways across your work, working around the brighter colors, in between and throughout your work almost like the matrix of a woven rug or the steel structure of a high-rise building, pulling the piece into unity and harmony. An unbelievable number of grays are available simply by mixing opposites or complements. Diluted blacks can give neutral grays, but in most cases these do not create the impact of mixed grays.

Try this exercise of taming greens by mixing them. Put out small amounts of all the following colors:

Yellows: yellow ochre, cadmium yellow, lemon yellow, and new gamboge.

Browns and black: raw sienna, raw umber, and ivory black.

Blues: cerulean blue, cobalt blue, ultramarine blue, phthalo blue, and Antwerp blue.

Greens: viridian green and phthalo green.

Reds and orange: rose madder genuine, alizarin crimson, light red, cadmium red light, Winsor red, and cadmium orange.

Fill a full sheet of paper with 1 × 2" (2.5 × 5 cm) rectangles from one end to the other.

1. Mix each yellow with small amount of black.
2. Mix raw sienna and raw umber with black.
3. Mix each blue with each yellow. Try different concentrations for different effects.
4. Go back to the same yellow/blue combinations, and this time add small amounts of various reds and orange.

Neutrals can be wonderfully transparent and clean. Muted hues are particularly effective when played adjacent to high-chroma colors.

5. Try viridian and all yellows.

6. Try viridian and all yellows and all blues.

7. Try viridian and all yellows and all blues and various reds.

8. Try phthalo green and all yellows.

9. Try phthalo green plus reds plus yellows.

10. Try phthalo green plus reds.

11. Try phthalo green plus reds plus yellows plus blues.

12. Try phthalo blue with all yellows plus small amounts of reds.

I like to repeat a dominant varying color throughout my painting. It is easier to liven up a unified but slightly monotonous color scheme than to pull a chaotic color scheme together.

COLOR MANAGEMENT

You must really know the keyboard before you can type 80 words a minute. Because watercolor dries fast, things happen faster and are more irreversible than with a slower medium. Therefore, it is essential that you know your color keyboard and

how each color reacts alone and in combination with other colors. The ability to make quick color decisions is imperative when you are seeking a rich, glowing watercolor.

Simultaneous contrast. As you paint, constantly study what each passage will touch along the way. Be aware of simultaneous contrast, a phenomenon that occurs in the viewer's eye when a full-strength color is placed next to white or a neutral. The white or neutral will take on the property of the color's complement. For example, a bright red placed next to white will cause the white to appear cool, or greenish; conversely, a bright cold green placed next to white will cause the white become very warm, or reddish. Take advantage of this optical phenomenon in planning your paintings.

Receding and advancing colors. Darks usually recede in a painting but can be brought forward by grayed, high-key backgrounds. Cool colors normally recede but can be brought forward by using an intense hue against a pale background. Warm earth colors placed over cool staining colors

These warm to cool neutrals were all laid down in one pass, the key to glowing grays.

will look muddy and grayed, while cool stains over warm earth colors will look much better.

Achieving deep darks. For deep darks, use the smallest addition of water possible and apply the color on dry paper. Some deep dark combinations: alizarin crimson and phthalo green, phthalo violet and viridian green, ultramarine blue and alizarin crimson and phthalo green. In trying to achieve a dark mixture, remember that a color mixture can be only as dark as its darkest component.

LIMITED PALETTES

You don't need to feel cramped by using a limited palette. In fact, by its very composition, such a short range of colors can promote increased harmony and unity in your work.

Simplify your palette if you have a tendency to use too many colors. It's often wise to restrict yourself to a limited palette. Many great masters have limited themselves to just a few colors: Cézanne, Daumier, Rembrandt, Wyeth, and many others. On the other hand, do continue to experiment with different combinations; a color change may surprise you. We all fall into color ruts. Trying a new palette may bring fresh life to your work.

Here are eight very interesting limited palettes. Make a point of trying them.

1. Yellow ochre
 Light red
 Ivory black
 Phthalo blue

2. Phthalo violet
 Viridian
 Vermilion
 Yellow ochre

3. Burnt sienna
 Ultramarine blue
 Yellow ochre
 Ivory black

4. Rose madder genuine
 Cobalt blue
 Aureolin
 (This is a very transparent combination.)

5. Cerulean blue
 Alizarin crimson
 Viridian
 Yellow ochre

6. Neutral tint
 Raw sienna
 Venetian red

7. Raw sienna
 Burnt sienna
 Ivory black
 Cobalt blue

8. Lamp black
 Naples yellow
 Alizarin crimson

Here are some additional color combinations:

9. Sepia umber
 Phthalo green
 (This combination yields transparent darks.)

10. Sepia umber
 Cadmium orange
 Cadmium yellow deep

11. Phthalo blue
 Sepia umber
 Hooker's green

12. Phthalo blue
 Cobalt blue
 Light red

13. Phthalo blue
 Cadmium orange
 Hooker's green

14. Phthalo blue
 Phthalo green
 Alizarin crimson

15. Alizarin crimson
 Phthalo blue
 Hooker's green

16. Vandyke brown
Phthalo blue
(This combination yields good darks.)

17. Payne's gray
Raw sienna
Light red

18. Raw sienna
Venetian red
Neutral tint

19. Yellow ochre
Burnt sienna
Ivory black
Cobalt blue accents
(Velazquez loved this combination.)

20. Lamp black
Naples yellow
Alizarin crimson

21. Phthalo green
Alizarin crimson
(Mix these to get exciting blacks.)

22. Winsor emerald
Indian red

Here are several good combinations that will yield varying neutral grays.

23. One part new gamboge
Three parts violet

24. One part cadmium orange
Two parts cobalt blue

25. One part red
One part green
(Try all reds and all greens.)

26. Prussian blue
Burnt sienna

27. Phthalo blue
Burnt sienna

28. Neutral tint
Sepia
Raw umber
(Yields silver grays—an interesting combination.)

29. Cerulean blue
Small amount of alizarin crimson
(Yields pearl gray.)

Grays can also be produced by diluting blacks, but mixed grays are more interesting.

PAINT QUALITY

What is meant by the term "paint quality," often used by jurors to describe prize-winning paintings? The term means the excitement and vibration created by the pigments on the work surface. Jurors use the term when they see unusual clarity, subtle movement, and modulations of paint, combined with exciting hue and value combinations in selections of paint applied.

How can you improve your paint quality? The simple, most valuable method I have found in watercolor work, and the one most neglected or forgotten by most new painters, is putting down the correct value and hue the first time and never going back into it again! Make a decision, never a tentative stroke. It's often better to be boldly wrong than tentatively correct. The fearful stroke breeds problems, and the scrubbed-out areas are always visible. Repainted areas are never as clean and exciting.

Every time you have to go back into a passage, you reduce the amount of light that is coming through the pigment from the white paper, thereby deadening the glow or luminosity with each successive layer. Transparent glazes do the least damage to paint quality, while opaque colors (such as cerulean blue, Indian red, and yellow ochre) do the most damage. As long as you keep the passage wet, you can continue to modify shapes, hues, and values without destroying the transparency. But once it is dry, each successive application will take its toll on paint quality. Also avoid pushing your color into the paper by putting pressure on your brush. This damages paint quality too.

GLAZING

Glazes work best with the most transparent colors. In this method the artist lays down washes of color one at a time over part or all of the painting surface, waiting for each layer to dry before applying the next one. Of course, each layer creates a new version of colors; for example, blue glazed over yellow creates a green area.

This method of working has the advantage of creating a very luminous surface even into the darker tones, provided you stick with the transparent colors. It is one way to keep your paintings fresh and vibrant. Its limitation is that it creates hard edges, but this can be overcome in two ways. One way is to paint across lines to create a transition area of hue and tone at the edges of each shape. Another way is to keep washes close together in value as you add each additional glaze.

Remember, opaque sedimentary colors don't lend themselves to this method. It's better to stick with cobalt blue, phthalo blue, rose madder genuine, alizarin crimson, viridian, aureolin, new gamboge, and other more transparent pigments.

Here is a design drawing of the odd little brass lamp I chose for this glazing demonstration. The lamp was made from a plumber's blowtorch.

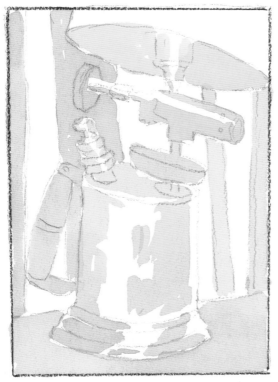

I painted the first layer with cadmium yellow light.

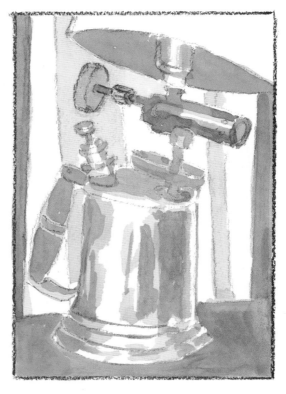

After the first layer was completely dry, I did a second layer. This time I mixed the cadmium yellow light with cadmium orange and cobalt blue on my palette to achieve a medium brown. Note how the first layer remains visible through the second one because of the transparency of both colors.

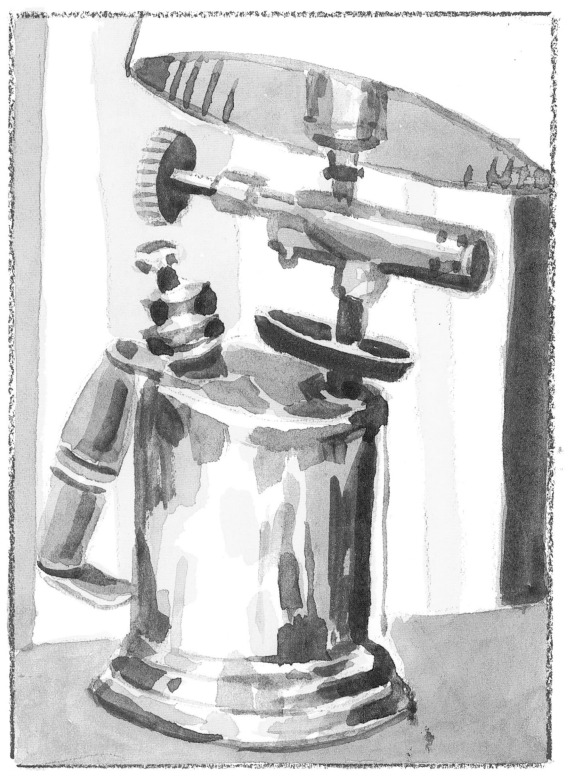

Here is the final stage. Again, I waited until the preceding step was completely dry before adding the final color: the same as the second stage but with more blue and less water. The completed piece captures the brassy glow of the little lamp.

COLOR AND MOOD

Color affects—even determines—the mood of a painting. Although people's reactions to colors are highly individual, here is one set of possible color associations:

Green: Can lean toward cool or warm; much like blue, passive, restful, young, growing.

White: Highly visible, light, airy. Purity, innocence, truth.

Black: Deep, silent, depressing. Sorrow, death, evil, terror.

Gray: Mellow middle ground between white and black, most pleasing when worked against pure or nearly pure color. Having decided on the high-chroma accent, add a little of its complement to tint neutral gray and you will show the brilliant glow of the pure color to its best advantage.

Yellow: Most luminous color, least popular especially in dark shades. Clear yellow is cheerful, bright, active. Dark yellows are associated with cowardice, illness, envy, and deceit and are generally disliked.

Red: Strongest chroma. Greatest visibility and attraction. Aggressive, strong, active, sexual, courageous. Strife, danger.

Purple: Rich, stately, royal, retiring, receding, cool.

Blue: Cool, quiet, passive, spiritual.

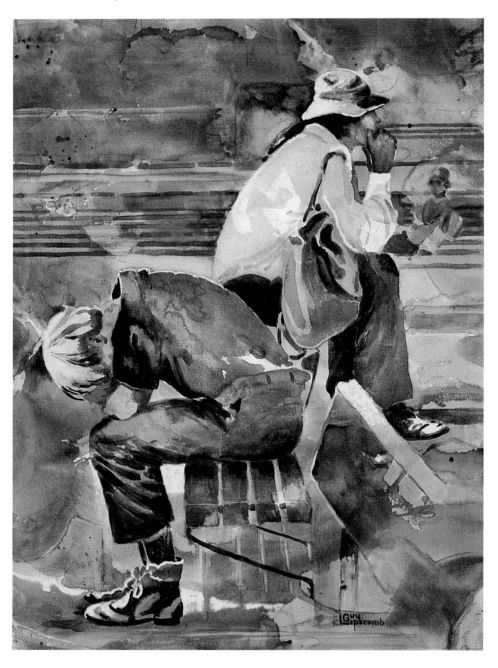

A BAD DAY. Watercolor on Arches 140 lb. cold-pressed paper, 22 × 30" (56 × 76 cm). Collection of the artist.

The bad day portrayed here could be right after exams, as students anxiously await their grades. Neutral color dominance and stillness convey the mood of this situation. The horizontal lines of the steps and the limited oblique lines of the figures further emphasize the apparent dejection.

COLOR CHORDS

A color chord is best described as a combination of colors that follows these basic principles of design: (1) dominance of a hue, (2) varying value in the colors, (3) varying chroma or brightness, and (4) varying the color intervals or distances from each other on the color wheel. Equal distances or intervals between colors make for boredom, while unequal distances create interesting rhythms. Color balance is obtained by having the large color area the weakest or most modified color, played against small color areas of a stronger chroma. The largest area normally sets the basic dominant color for the picture, which could either be neutral, warm, or cool.

What we know of color organization principles should supplement but not replace our own sensitivity and taste. What we call color chords are just combinations based on ancient principles of unity, rhythm, and variety.

Some pros make a series of small paintings, using the agreed-upon design, seeking the best color combinations or chords to use. This may seem time-consuming but it actually prevents larger, more time-consuming errors. Many good designs have been wrecked by a poor choice of colors, ones that just don't convey the mood you want, ones that are not harmonious, ones that are too bright or too dull, or too dark or too light. The more certain you are of your color chords (not just which colors to use but how much to use where, and how they relate to one another in size, value, and chroma), the better your chance of a successful painting.

TIPS

- It is important to distinguish between darkening a color and graying a color. Your eye is often fooled into thinking that less intense color has become darker. Blacks will darken a color, but the complement will gray or neutralize a color.

- If your goal is to have the viewer respond to color, keep values close together.

- Cast shadows often appear darkest on their edges and can vary in temperature inside shadow shapes.

- Judge a color in relationship to its surroundings. For example, a red that seems weak on your palette may appear bright and intense when placed next to a green.

- When mixing, try to use colors that are close in value to the final mixture. In other words, use a light blue to make a light purple.

- Separate shapes with value, hue, tint, or tone wherever possible. These methods are usually more effective than line, although line is very useful too.

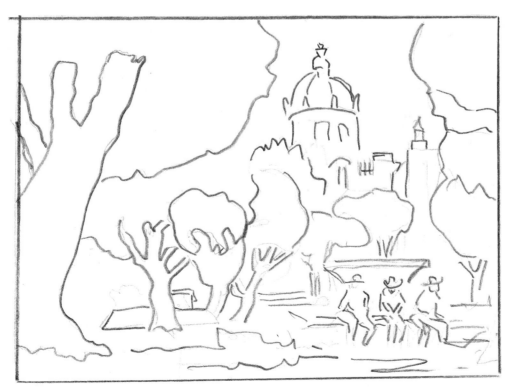

Like most Mexican towns, Moralia is dominated by the cathedral, which is impressive but very hard-edged. Here you see my design drawing. The men in this public square were enjoying the birds, the surroundings, and the passers-by. They provided scale and interest for me.

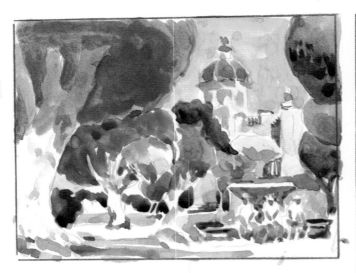

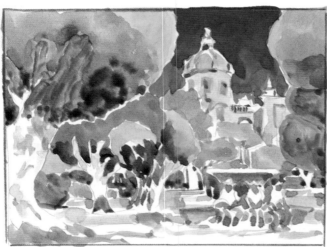

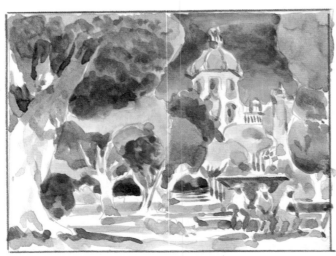

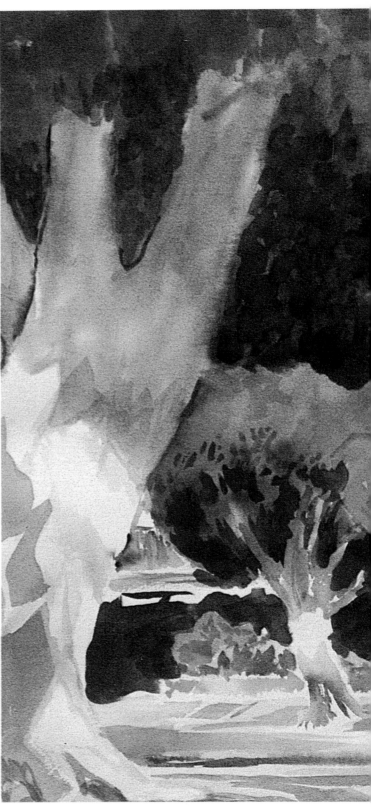

Here you also see several of my experiments with color chords for this design. I was striving for balance and harmony, a unified whole, and it took me several attempts to find the right combination.

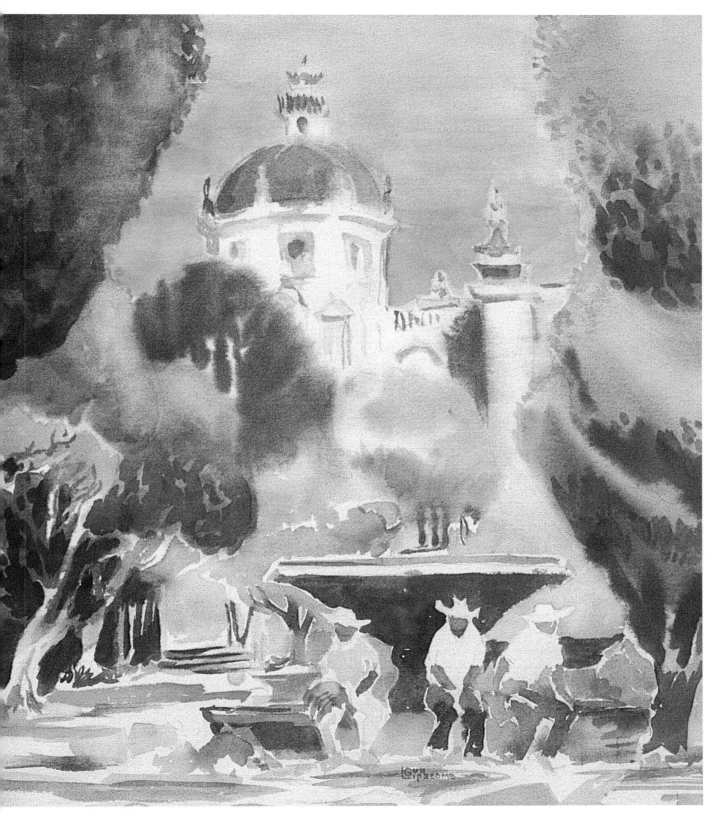

CITY SQUARE, MORALIA, MEXICO. Watercolor on Arches 140 lb. cold-pressed paper, 22 × 30" (56 × 76 cm). Collection of Transco Energy Co.

I finally chose the Indian red sky as the complement to the large green tree shapes. This type of painting is what I like to call a "visit recall" landscape, and doing it makes an indelible memory of the place and time.

This design drawing was done at Myrtle Beach, South Carolina. These figures were all fishing but not in the same part of the thousand-foot-long fishing pier. I grouped them together to make an interesting design with overlapping forms. The big man attracted me first because I felt sorry for the cushion being squeezed beneath his weight.

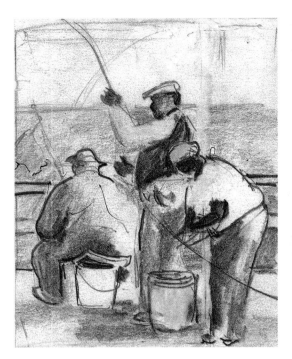

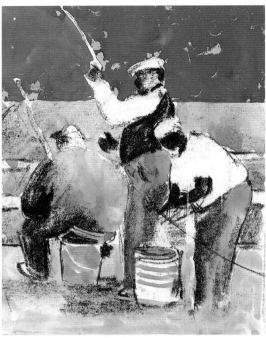

You will usually not have time to explore various color chords on location, and this is why you should have a vocabulary of them to fit various moods and weather conditions. This particular day was overcast with almost no color contrast between water, sky, and pier, so all options were open. Here are three of the color chords I tried.

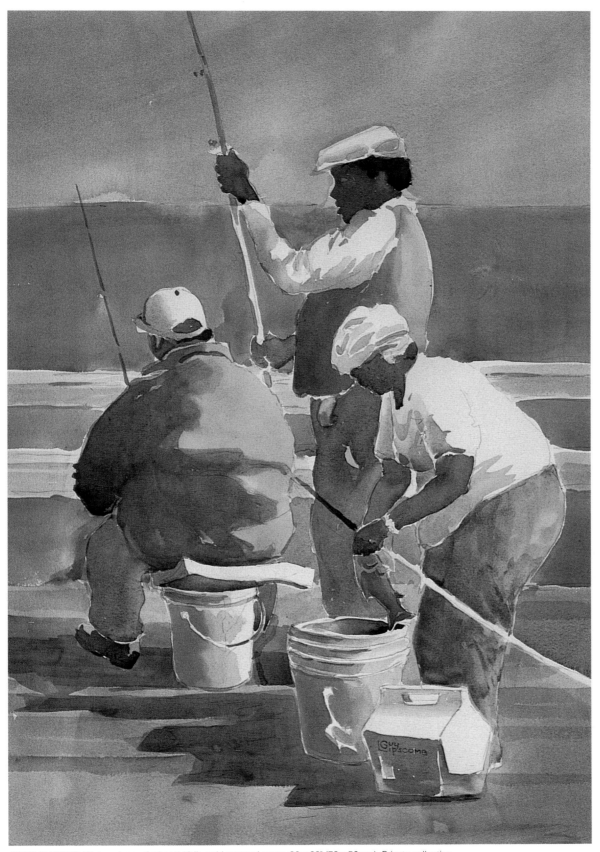

FAMILY AFFAIR. Watercolor on Arches 140 lb. cold-pressed paper, 30 × 22" (76 × 56 cm). Private collection.

My final choice was a warm sky color. This piece and the trial color chords were done out of the wind in the studio. Only the drawings were done on location.

Making Design Decisions

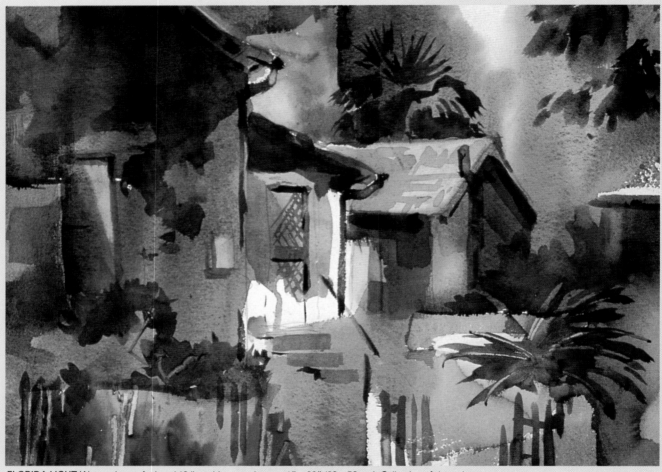

FLORIDA LIGHT. Watercolor on Arches 140 lb. cold-pressed paper, 15 × 22″ (38 × 56 cm). Collection of the artist.

*"A painting that is well composed
is half finished."*

—Pierre Bonnard

Once you decide you like something well enough to paint it, you have to make a strategy decision. How are you going to attack the problem? Of course, your strategy may change during the course of the painting, but you must start with some kind of game plan.

Why compose? In any literary work, words necessarily follow in a logical order, and ideas develop one from another in a sequence of actual time. Music, like writing, is a time art. But painting is static and without time, a space art with all its elements seen simultaneously. To give life to this static two-dimensional area, it becomes necessary to create some kind of visual order by controlling the lines, shapes, and directions of pictorial composition so as to simulate time where there is no time. To express visual ideas harmoniously, you must capture the interplay of the various design elements—size, shape, value, direction, texture, line, and color. A true work of art is always complete, a unified whole endowed with a mysterious ability to renew itself.

The essential components of good art are structure and emotional feeling, the latter being the more difficult to express. These two are followed by a sense of rhythm and motion generating interest over the whole working surface. Always remember as you design a painting that every shape, line, tone, or color is a force that pushes or pulls in one way or another, or acts as a stabilizer so that the total piece is held together in unity, harmony, and balance. We often think only of balancing forms, but lines, forces, and rhythms are equally important in achieving unity and balance.

A CHECKLIST OF DESIGN DECISIONS

Design decisions are made in every work of art. They are often made subconsciously after years of practice, or they can be made deliberately and painstakingly. Many painters start out using the more tedious method of decision making, and as they mature, they rely increasingly on intuition.

Because of the fragile nature of watercolor, young painters greatly increase their risk factor if they rely on intuitive decisions alone. The very fact that watercolor paintings progress rapidly at some stages means that certain decisions must be made very quickly, and this greatly increases the risk of mistakes. But every watercolorist must make these decisions and accept the risk. Take a few minutes

TIPS

- A complex composition generally demands simple color, while a complex color scheme is best expressed in a simple composition.

- Don't paint something the way you see it. Paint it as you would like it to be; exaggerate what excites you about the subject.

- Even though most of your subjects will be three-dimensional, always think in two dimensions, because you are limited to your two-dimensional working surface. Learning this perceptual trick is the first step toward analyzing your work as a unified composition.

- Darks can unify or destroy a painting. Go slowly when deciding on size, shape, and location of darks. The same story applies to whites. They can unify or fracture your design.

- It's not a bad idea, if you are a new painter, to reduce your plan to words—write it down! Maybe even name the painting so that you will keep your thoughts focused on the foremost reason for doing the work in the first place. I have seen many students start with one theme and wind up with four or five of equal importance in the same picture.

and review many of these listed decisions you make, whether consciously or subconsciously. Each is important to the final success of your painting. After an introductory list, we'll look at each area a little more closely.

- *Size decisions* (frequent error for beginning painters)
 Size of the painting surface
 Size of the main points of interest
 Size of the secondary points of interest
 Size of the negative, supporting shapes
 Size and type of the supporting lines

- *Shape decisions*
 Shape of the painting surface
 Shape of the dominant element or elements
 Shape of the supporting or secondary elements
 Shape of the negative elements

- *Value decisions*
 Value of the major elements
 Value of the minor elements
 Value of the negative areas
 Value of the textures
 Value of the lines

- *Direction decisions*
 Dominant direction of lines
 Dominant direction of shapes
 Dominant direction of color gradation

- *Texture decisions*
 Texture of the main area
 Texture of the secondary elements
 Texture of the negative areas

- *Line decisions*
 Line used to create rhythms
 Line used to emphasize shapes

- *Color decisions*
 Dominance of color in the total picture (warm, cool, or neutral)
 Broken or grayed color areas
 Accent decisions: size, chroma, value
 Vibrations or discords: size, chroma, value

SIZE OR MASS

This decision is independent of the subject matter. The center of interest does not necessarily have to be large on the picture plane, but if it is small, the other shapes must be well designed and supportive. The most common error in my classes is making centers of interest too small, with little thought about the huge, uninteresting negative shapes. This size decision can make or break the success of your work. It is far better to make your main center of interest too large than too small. Small centers of interest often use value and color rather than texture to hold their position as focal points.

SHAPE

Shape decisions begin with the shape of the picture format itself, which often relates to the subject matter. You would probably never try to paint a tranquil water scene on a narrow vertical format; you would be working against the mood you were trying to convey.

Constantly look for intriguing shapes in your subject matter, and if they are not there, invent them yourself! If a subject has caught your interest, you should study it from all angles so as to get the best understanding of shape options open to you. As you begin to put your subject matter together, be aware that you are creating shapes between your objects, called negative shapes, which should be just as interesting as the positive shapes. Work hard on background negative shapes.

One of the most common failings of beginning painters is *predictable* shapes. Nothing will kill the excitement of your work faster. In most work, there should be a variety of shapes with some *repetition with variation*. Look for descriptive edges, interlocking shapes, a filigree of lacelike components that describe the interior of an object by describing its exterior shape. Constantly strive to create new shapes by overlapping forms without destroying their identity. Overlapping forms also create depth on your picture plane.

Try to place small shapes against large ones with some middle-size shapes along the way. It is usually preferable not to have many shapes of the same size, or too many shapes. A few interesting major shapes with variety are often sufficient.

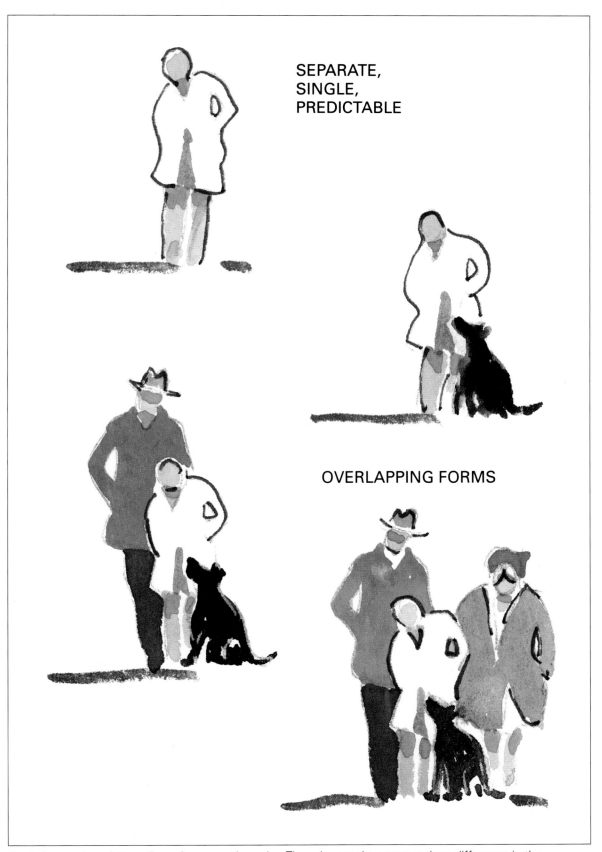

SEPARATE,
SINGLE,
PREDICTABLE

OVERLAPPING FORMS

Look for overlaps, interesting edges, see-throughs. The edges make a tremendous difference in the excitement of your design. They describe the interior of the material and should interlock with other shapes the way a jigsaw puzzle fits together. They add interest and depth to a design.

VALUE

Nearly all watercolorists make errors in the use of value, probably because watercolor often dries about two values lighter than it appears when the pigment is wet. We can all take note of the saying, "In watercolor, if the value looks right when it's wet, it's wrong!" Acrylics and casein don't change as much in value after drying. Many of the value errors are made in the light, high-key washes, which wind up too light, and the dark areas, which usually wind up being too middle-tone.

The second most common error in the use of values is to jump too quickly from light values to dark ones without going through a transition area of middle tones. You should work in middle values as long as possible, making them as masterfully wonderful as you can, reserving the lights and even delaying painting the darks until

the very last stage. This is the reverse of the way you would paint in oils.

On your next painting, try painting the background shapes mostly in middle tones before doing any work on your main subject matter. See how interesting you can make these background areas of your piece. Most paintings consist of mostly middle values anyway, and how these areas are painted will determine the quality of the finished work. (I will often put a small dark spot in a known dark area just to have reference value and then gauge all the other values from it.)

Try to construct light and dark passageways in your work. These become channels for the eye to move over the painting. They don't have to be continuously connected but may be implied and discontinuous. If you don't think about this aspect of darks and lights, it is very easy to end up with a very spotty design lacking unity.

Values really place objects in space on your painting surface. Light values normally are convex or come forward from the body of the painting, while darks normally are concave or recede from the viewer. However, it is possible to have dark values come forward—if the subject is backlit, for example.

DIRECTION

If the predominant shape direction in the subject matter is horizontal, it is logical to use a horizontal format, and the opposite is true if the majority of the shapes in the subject are vertical. Oblique or angular direction can be used along with curved

TIPS

- To tell whether a passage is dark enough, take a card or your hand and cast a strong shadow over the questionable area and then judge it again. If the passage seems too light, glaze it to darken it. Repeat the test and glaze the area again if you are still not satisfied.

- Another method is to overlay the questionable area with a piece of wettable acetate film. This can be purchased at most drafting supply houses or art supply stores. Paint a darker value of the color, to see if it looks better, directly on the film and then make your judgment without having to disturb the painting.

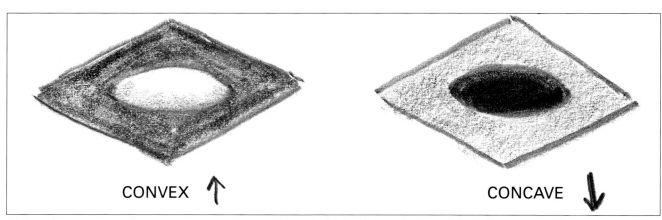

CONVEX ↑ CONCAVE ↓

Light values are normally convex or come forward from the body of the painting, while darks are normally concave or recede from the viewer. It is possible, however, to have dark values come forward—as with a backlit subject.

shapes and lines to depict motion or activity. Such a composition can be used with either a vertical or a horizontal format.

TEXTURE

A few repetitious shapes suggest a pattern, but when these shapes are repeated many times, you have created a texture. The texture of edges describes the interior shapes: Shingles on the edge of a house describe the whole roof; mortar joints on the edge of a brick wall describe the rest of the wall; leaves on a tree's outermost branches tell us much about the entire tree.

Texture gives more information that helps the viewer understanding and identify a shape; it also creates visual interest in a shape without distorting it. Texture is best described as the connecting words of the poem and can indicate a lot about the painter's personal emotions about the subject.

The transition area where the value is changing from light to dark is an especially good place for texture, although texture may be used almost anywhere in your work.

LINE

When is a line more than a line? When it modulates in value, size, color, edges, continuity, or direction. I don't know when a line becomes fat enough to become a shape, and I don't think it matters. The important thing is to remember to use every option of the line because it is an extremely valuable tool in your work.

Line can establish a grid or trellis on which to hang your subject matter. Line can set up a rhythm within the painting or imply direction. Line doesn't have to be continuous. I am convinced that the line is neglected, particularly in watercolor painting. Many teachers discourage using line in watercolor, feeling that it is a crutch in an attempt to rescue bad value painting. I think that this is a throwback to when watercolor was used primarily to tint line drawings. There is a tremendous difference between a line and an outline! Make line work for you! However, don't overwork it and allow it to become repetitious or dull. If the values in a painting don't properly separate shapes, there is a temptation to outline. Resist it! Check your values.

COLOR

Color really brings things alive in your work; color is magic in paint. Beautiful, sensuous color can do much to help rescue a rather poorly designed painting.

How many color combinations are at your fingertips? Would you be surprised if I told you a thousand? How about *ten thousand?* Probably more! How many do we use? Not too many, probably not as many as we could or should. This is not to say that you should use all the rainbow at one time. Remember, wonderful paintings can be done with just a few colors. Often an artist's palette becomes part of his or her signature, as with Corot or Gauguin.

Subtle changes of color can make for a much more exciting painting. Artists cannot separate color decisions from design decisions. Remember, one small spot of brilliant color will balance a very large area of neutral gray, so color, size, and shape have to be considered together at the very beginning of your work.

BASIC DESIGN SCHEMES

Painters have certain tricks of the trade for designing a picture that works. For example, one of the oldest ways to strengthen a design is to place two important directional lines in such a way that if continued or extended they would meet at something close to a right angle. This has a way of locking or consolidating a design, building a kind of a lattice skeleton to support the final effort. Another way to build a composition is to start out by drawing the center of interest and then carefully add shapes to that center, being fully aware of every positive and negative shape.

Rex Brandt's excellent book *Seeing with the Painter's Eye* describes five basic patterns of picture organization. Most successful paintings fit into one of these: (1) vertical dominance, (2) horizontal dominance, (3) cruciform dominance, (4) framelike dominance, or (5) checkerboard or pattern painting.

I have added a few more variations of basic designs that have been used successfully for centuries. Feel free to try them—or to experiment with your own.

Here are six design schemes: Small light (sailboat and house) within large dark (mountain) within mid value (water and sky).

Dark (building and trees) within mid value (foreground and sky).

Small dark (house) within large light (big building) within mid value (foreground and sky).

Small light (house) within mid value (foreground and mountain) against dark (sky).

Large light (house) in mid value (foreground and background).

Gradation of light to dark.

More design schemes: Three sizes, three shapes.

Framed space with openings.

Large shape close to the center for balance.

A backlit silhouette.

Lines radiating from a point.

Formal balance, where there is equal weight on both sides of center.

Major vertical located by rotating vertical onto horizontal.

L dominance.

Tunnel vision: subject framed by dark areas, with a break in the encompassing shapes to provide entry.

Horizontal dominance.

Massed shapes.

S dominance.

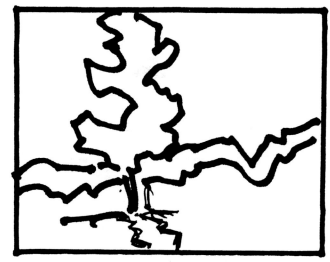

Static cruciform design.

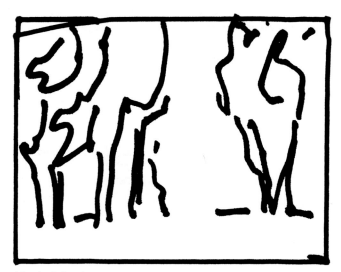

Vertical dominance.

Dynamic cruciform design.

Overall pattern—checkerboard.

CREATE PATHWAYS FOR THE VIEWER'S EYES

Plan how the viewer's eyes will enter your picture and wander through it to discover unexpected areas of interest. Light is a great unifying force that will help you accomplish this. Designing with an eye for light paths is difficult, but it is well worth learning because it improves eye circulation significantly.

When you start any rectangular or square painting, you automatically have four lines crossing. Your eye wants to go where the lines cross, so the corners are very important. Use variety, turnarounds, and recessive textures to bring the viewer back into the body of the painting.

Dark is the absence of light. It's the dark doorway, empty well, or tunnel. Dark recedes, shrinks, or clutches—but it can also be used as a roadway inside the painting. Rex Brandt phrased it, "Dark shapes work best reaching partially around lighter areas, acting as reinforcing supports. Darks shaped like L, U, V, C, or J will reinforce the lights inside their shapes."

The viewer almost always sees the light material first in a painting, then the darks, and finally the middle tones.

TENSION

Knowledge of the principle of tension has freed modern painters from the old theory that cool, recessive colors should be used only in the background and warm, advancing colors should be used only in the foreground. Although you should be aware of a color's tendency to advance or recede, you can use any color wherever you want if you plan the tension in your painting. The viewer's eye will be drawn from one area to another by similar colors or similar values, both light and dark. This works with shapes, lines, masses, and colors. Artist, author, and teacher Lois Bartlett Tracy once phrased it, "Tension, the heartbeat of modern art, not only produces balance but adds vitality, excitement and a living, breathing quality."

Every composition is an organic structure, and each object within that structure must be placed in relation to the tension it exerts on every other object. Thus an image that seems to fall off the paper in any direction can be held within the picture by a counterpull in the opposite direction. A large mass, an insistent line, a dab of strong color, or a larger area of similar but lower-intensity color will produce the necessary tension when correctly placed.

Tension creates stress in the areas where it is used, adding life and interest to your work by interrupting its order. This example uses distortion from the vertical and horizontal to create interest and action in the drawing. Notice how often movement or line in one direction is countered by a line or shape in an opposing direction. It's very important to establish these lines and rhythms before going forward with the painting process.

(The lattice squares on this drawing were put there only to emphasize the movement of the shapes in the value drawing.)

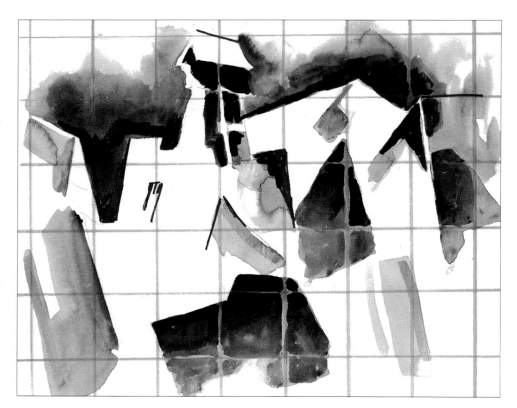

SAY MORE—PAINT LESS

The vignette has somehow been given a bum rap. It has been labeled a cop-out by many critics and teachers, but I'm not convinced that they are right. It really depends on your definition of vignette. If you are talking about what the photographer calls a vignette—an image that fades gradually to white on all sides—I'll agree, it's a cop-out. It looks unfinished. (Charles W. Hawthorne, teacher at the Cape Cod School of Art during the early part of this century, once described the vignette as "an oyster in full flight.") However, if you label as a vignette a painting that touches three sides of the paper with a good deal of white paper left for viewers to have pleasure filling in for themselves, then I don't believe such a piece is a cop-out. The artist is designing the negative spaces just as much as the positive ones, and Hawthorne's description just does not apply.

The key to a successful watercolor vignette is to be sure that the interior lights or whites are more interesting than the unpainted areas on the outside of the images. You will have to work extra hard to design your interior lights so excitingly that viewers are forced to hurdle the exterior lights to enjoy the interior lights, shapes, colors, and textures. Use simultaneous contrast to tint or tone these white areas for the viewer, and the luminous quality of the watercolor will be enhanced.

Most vignettes work best with hard and soft edges, but exciting hard-edged vignettes can be made. The key to success is the design of the edges. They must be wonderfully captivating.

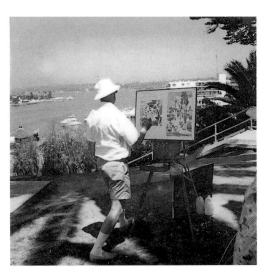

Here is a photograph I took of Rex Brandt doing one of his exciting on-site demonstrations. He's six feet four inches tall, and I wanted to emphasize his swaying gestures as he worked.

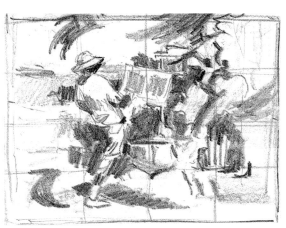

Exaggerated gesture adds life. I left out a lot and added touches to enhance the design.

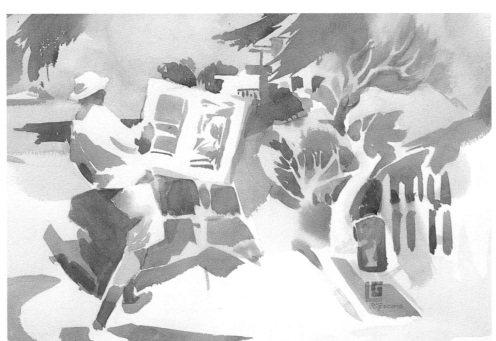

PAUSE TO REFLECT. Watercolor on Arches 140 lb. cold-pressed paper, 15 × 22" (38 × 56 cm). Collection of the artist.

I think the finished vignette captures the moment well with minimal paint. It is hard-edged, but the edges are interesting in their own right—yet not so interesting that they overpower the excitement of the interior of the piece.

OVERLAPPING SHAPES

What are the most important places in your painting? I believe it's where each shape touches another shape. It's the equivalent of where the referee throws up the basketball to start the game, or the time when two boxers touch gloves before the fight, or where the net divides the tennis court. What happens in value, color, texture, shape, and direction in those areas of transition has great effect on the outcome of your painting. Done well, these areas can make your work a success; done poorly, these areas will fragment and destroy a fine concept, design, and composition.

Rex Brandt made me realize how important it is to see a number of overlapping objects as a single, more interesting shape. Such overlapping shapes make exciting new shapes without necessarily making the component shapes indistinguishable. Of course, this overlapping of forms not only creates more interesting profile shapes, but also creates space by placing one shape behind another. The "focus" often determines your picture's central theme. Seldom should everything be finished the same way. Some shapes should be out of focus, some very much in focus.

Decide what's to be in focus and what is to be fuzzy. These two pictures were taken in my studio, with the camera pointing in the same direction. However, in one instance it was focused on the background and in the other instance on the foreground. The results are dramatically different!

Decide where your real main center of interest is going to be. If it is in the foreground, the middle ground should be less sharp in focus. If it is to be in the middle ground, the foreground will probably have soft edges. The human eye, like a camera, cannot see sharply at all distances.

SHAPES SUGGEST MOOD

Elongated rectangular shapes placed either vertically or horizontally in a painting suggest tranquility and stability, like tree trunks or lakes seen from a distance. Curving shapes, and shapes with angles other than right angles, create action and movement. So do most shapes when placed at oblique angles to one another. Even circles, squares, and triangles convey a mood of action if placed at oblique angles.

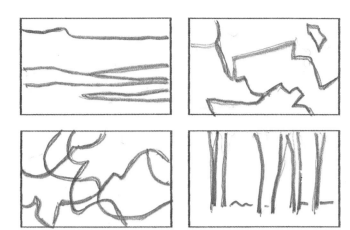

Shapes have a significant effect on mood. Think about this as you plan the design of your paintings. Above are four examples. Top left: quiet, calm. Top right: active, exciting. Bottom left: musical, poetic, rhythmical. Bottom right: uplifting, majestic, strong.

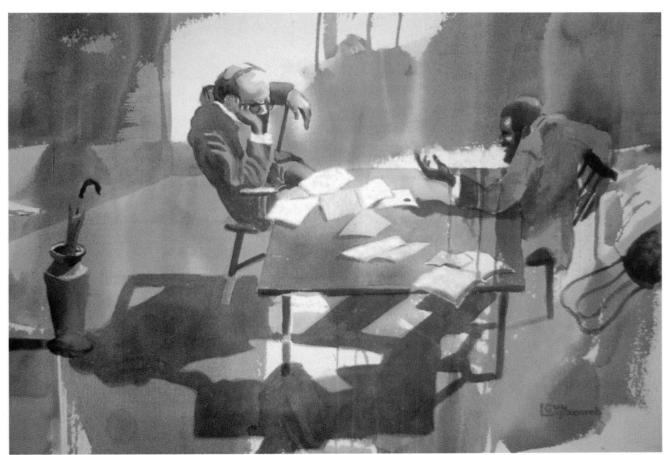

THE SALES PITCH. Watercolor on Arches 140 lb. cold-pressed paper, 14 × 20" (36 × 51 cm). Collection of Alex Powers.

The gestures and shapes of the two men quickly establish the mood of this painting. The salesman's arm is turned upward in a pleading gesture, while the other man's hand dangles downward to suggest doubt and disbelief. Both are slouched in their chairs as if they've been at the table a long time. The silhouette of the major shapes plays an important role in setting the mood of a painting.

DESIGN VERSUS PERSPECTIVE

There are a number of ways to depict depth; perspective was used extensively for most of the Renaissance. This convergence of parallel lines was perfected by Paolo Uccello, an Italian painter in the mid-fifteenth century. Before that time, distance was shown by overlapping forms or by progressing from the bottom of the canvas to the top with the bottom being close, the top being distant. Many modern painters downplay distance and perspective in their work, making a conscious effort to relate the picture to the flat painting surface itself. The purpose of this is to focus on the overall design of both positive and negative spaces and to downplay perspective. The two paintings shown here contrast these two approaches.

CHILD'S PLAY. Acrylic and watercolor on Arches 140 lb. cold-pressed paper, 22 × 30" (56 × 76 cm). Collection of the artist.

This painting was inspired by preschool drawings at a state fair. It has no perspective or depth, but emphasizes design to tell its story of the freshness and charm of children's imaginations. Shape, color, value, and texture play major roles on a flat surface.

HILL VILLAGE. Watercolor on Arches 140 lb. cold-pressed paper, 22 × 30" (56 × 76 cm). Collection of the artist.

Perspective using vanishing points and narrowing lines is clearly shown in this painting of an imaginary hill town. Here the lines of the street and buildings clearly create a three-dimensional painting. There is no such place, but I enjoyed the visit.

Finding Ideas for Paintings

CALIFORNIA PINTOS by Millard Sheets. Watercolor on Arches 300 lb. cold-pressed paper, 29 × 41" (74 × 104 cm). Artist's estate.

> *"Creativity requires that you stop paying general attention to everything and start paying specific attention to some one thing."*
>
> —Bill Moyers

Every time you begin a painting, something has to move you to action; something has to trigger your emotions and make you want to share an original viewpoint with others. This visual idea has to be strong enough to sustain you through the entire painting process. It is often called the motif of the effort, the motivation or heart of the painting. The motif could be lines, textures, pattern, shape, hue, or tone—and it is not necessarily the subject matter. It should call attention to itself and sustain the viewer's interest.

"But I'm not very original," I often hear in my classes. You are a lot more original than you realize if you will slow down your eye movement and become a lot more curious about what is around you. Try to separate forms into their components, to isolate some of the hidden wonders of nature around you, to rearrange what you see and select the most exciting shapes, to enlarge what you like and discard the rest. Every one of these activities requires invention on the part of the artist.

The key to your success is how eagerly and earnestly you commit yourself to becoming a more curious and imaginative observer. Improve your abilities to see and appreciate the abstract shapes all around you—and you will be well on your way to self-expression in paint.

DEVELOPING AS A PAINTER

All painters develop in stages or phases; learning the methodology of drawing and painting skills always comes before inspired vision, expression, or concept.

Phase 1: understanding the language and technique of painting.

Phase 2: developing design sensitivity and execution.

Phase 3: exploring uncharted waters. Some paintings may have what it takes to endure, but many do not. The important thing is to continue striving to convey a new insight to viewers.

Phase 4: becoming a truly great conveyor of feelings and emotions, a worthy goal seldom reached by even the most famous.

Decide what you want your painting to say. Do you want to make a political statement? Do you want to create a mystery? reenact a dream? talk about a past era? create a highly realistic statement? talk about a humorous situation? evoke terror, excitement, joy, sorrow, contentment, or tranquility? These types of questions must be very much up front in your mind as you start in on a painting.

THE CAMERA IS YOUR SLAVE, NOT YOUR MASTER

Most painters in the last hundred years have used their cameras as one of their tools in painting. The danger of it is believing that it can be a substitute for your drawings. It should never be your master, only your slave. Use it to record details, special shapes, and lighting situations. Remember that the camera sees the subject entirely differently from the way your mind's eye sees. There is no selectivity in a camera, so don't be trapped by it. I keep one with me most of the time, and my library of slides and prints is voluminous. I review these at intervals for ideas or starting points for pictures, but I haven't painted directly from a camera image in many years.

Photographs help me quickly capture form, pattern, texture, and value. I always use the camera when I don't have time to draw or sketch. Close-ups of nature's textures often provide designs of motifs from which I can build an effective interpretation of my feelings.

THE CONCEPT IS ESSENTIAL

Concept is the 'A' in Art—don't forget it. Don't pretend you can compensate for a worn-out concept with superlative rendering and strong technical abilities. Such things will often attract the uninformed, but they won't work in the long run. Before starting a painting, test your concept. Refer to the list of "cross-examination" questions on page 129 to make sure your concept is on target before you begin.

Every successful creation involves selection, decision making, choosing things that work with each other, balancing one thing with another to develop a truly worthwhile relationship. A highly skilled painter may paint directly and *seem* to be jumping over all the preliminary steps we have

been talking about. However, such painters are still weighing and balancing, judging and eliminating, designing and harmonizing all intuitively, a direct result of having done thousands of paintings and studied hundreds of thousands more. Some fine painters prefer to work this way, believing that the subconscious will dominate reasoned decisions and make the picture more sensitive to their true feelings. In time, you may want to work this way, but don't neglect the deposits of knowledge that must be there in order to be comfortable and successful with this kind of approach. Above all, slow down your eye movements and learn to see with the painter's eye. I have said this before, but it cannot be overemphasized.

NECTARINES IN THE AFTERNOON by Carolyn Lord. Watercolor on Arches 300 lb. cold-pressed paper, 15 × 22" (38 × 56 cm). Collection of Katheren and David Cox.

Here is realism presented in a simple way. The shapes are flat, simplified, and interesting, with an appealing use of moving color within them.

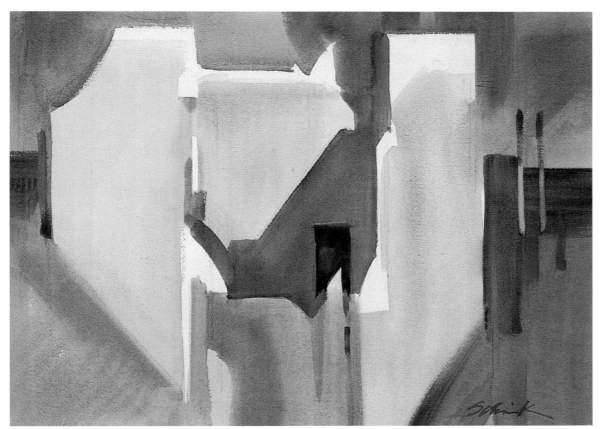

PECOS MISSION by Christopher Schink. Watercolor on Arches 140 lb. cold-pressed paper, 22 × 30" (56 × 76 cm). Private collection.

This painting expresses the essence of its subject without using any details. All details have been eliminated. The artist's strengths are simplicity of design shapes and interesting moving color, all mixed on the page.

SEEING RED by Marilynne Roland. Watercolor on Arches 140 lb. cold-pressed paper, 11 × 21" (28 × 53 cm). Collection of Daytona Beach Museum of Arts and Sciences, Daytona Beach, Florida.

Note the fine variety of simple shapes and colors in this painting. It is an excellent example of work done by a keen observer of the contemporary scene. Enjoy the rhythms of the fabrics with the stripes creating the background music at just the right intervals.

IMPROVING CREATIVITY

Let's talk about improving inventiveness and creativity, examining the things that can be learned and the things that are going to have to come from deep in the subconscious and from the accumulation of broad knowledge.

Unfortunately, there is a segment of contemporary work dedicated to the idea that novelty alone has value. Merely creating something new is not necessarily a worthy goal. Novelty must have new meaning, generate emotional response, be exciting to the viewer, if it is to have lasting value.

We all want to share our excitement for an idea or concept in a way that the viewer has never experienced before, a new revelation, a new viewpoint. Of course, inventive emotional insight and creativity are the catalysts that make it all happen.

Here are a few of the roadblocks to inventiveness that must be removed, as paraphrased from *A Whack on the Side of the Head: How to Unlock Your Mind for Innovation* by Roger von Oech (New York: Warner Books, 1988). Other writers and researchers have expressed similar ideas.

1. Fear of failure, of rejection, of painting less skillfully than it has been elegantly done before.
2. The need to conform.
3. Too little motivation, procrastination, never starting.
4. Too much motivation, action before thought.
5. Lack of discipline, failure to exhaust many of the options.
6. Intolerance of chaos.
7. Ignoring the value of daydreaming, thoughtful play with the pencil or the brush.
8. Relying too much on logic and reasoning.
9. Relying too much on your past successes. This is very deadening!

It won't happen to us by itself! We have to make a conscious decision to change from what we have been doing and thinking. We must say to ourselves, "I'm going to get out of my tired paintings and become a new hole driller." So often we find ourselves safely drilling in a tried and true hole somebody else has been working in for aeons! We need to try *new* holes, drill some of our own. No telling what you might find.

It has been said that nothing encourages creativity more than the chance to fall flat on your face without being frightened, judged, or ridiculed. To be creative, you need a sense of psychological safety. No matter how ridiculous or bizarre you may appear to yourself or others, you have accepted your own self-worth.

To be more creative, begin by letting down your guard. Let go of your self-consciousness. Be open to new experiences, become less of a conformist, and above all, *be willing to risk change.* To use words by Bill Moyers, "A good creative artist reinvents himself or herself every day!" Change always produces anxiety. If you have the desire to show the world your new vision, however, you must take that risk and never look back. It may never be great, but it will never be dull! The real battle is convincing the knowing public that your change has validity and merit.

We must pay attention to the unexpected. A keen observer once said, "If you know what you are always looking for, you will never see what you do not expect to find!" We must learn to really pay attention, and this means to expect without knowing what to expect.

Creativity blooms in an atmosphere of relaxed awareness. Train yourself to be more aware of your thoughts when you are half-awake, tired, or daydreaming. This is often a great source of imagery. Don't try to judge your ideas too soon, for creativity demands suspension of judgment on the idea—at least for a while. Most of us spend more time pointing out our ideas' flaws than we do generating new, better ones. Creativity requires a positive outlook, not a negative, judgmental one.

Guard against committing yourself to a good idea too soon. It's hard to stop when you are excited, but we have to remember that not all sparks start fires. Falling in love with your ideas too soon will often keep you from searching for a better one.

So often we think that we have to go to some exotic place to find the perfect motif for our next effort, but one look at Wyeth's or Cézanne's work

should dispel this notion in a big hurry! These artists took what they found close at hand and painted it in such a way that we enjoy looking at it over and over again. It was the way they presented their material that made the difference, not the uniqueness of what they saw. However, both of them saw with the painter's eye, which every painter should constantly strive to develop.

To excel at painting, one really must be obsessed. The idea must come first, however, or desire for expression is of little value. You must be willing to carry on a conversation with that precious idea. There really are few shortcuts. Our goal is to make our work appear to be much more than the sum of its parts, and successful paintings accomplish this.

GARDEN GATE by Judi Betts. Watercolor on Arches 140 lb. cold-pressed paper, 30 × 22" (76 × 56 cm). Collection of the artist.

This painting features beautiful shape selection and fine paint quality in soft colors. The artist has created a highly inviting scene using very simple forms.

FINDING NEW CONCEPTS

New concepts and ideas emerge from new techniques, from new materials, new surfaces, new combinations of materials. You can't worry about waste. Use, use, use lots of materials during this thoughtful play period, and the chances are that something will grab you that you can translate into an exciting new creation.

Do nothing about your idea, or in other words, sleep on it! This may help you germinate and cultivate a new idea. Do this, though, only after you have studied the problem as hard as you can. Recognize the power of incubation and use it properly. It's the lazy thinker who sits and waits for the flash of genius that probably will never come. I am a great believer that continuous effort is every bit as important as inspiration. Louis Pasteur put it this way: "In the field of observation, chance favors only the prepared mind."

Many young painters believe that creativity and inventiveness require great skill. Not so! This assumes that creativity and trained experience are the same thing. They are complementary, not the same thing.

We have been talking about the inspiration phase of creativity up to now. The inspiration is of no value if the development phase does not follow closely behind. This phase includes the hard work and discipline. You must learn to be a good technician; you must be fluent in the language of paint to be able to translate your wonderful ideas into reality. Don't discount your originality when you may simply need more time to gain experience, practice, and aesthetic judgment. You can be very original, far beyond what's happened up to now.

Creativity is not a function of superior intelligence, so don't let this myth slow you in your quest to become a fine painter. If you don't come up with a satisfactory answer today, calmly put the piece aside and keep looking at it out of the corner of your eye now and then, and the chances are that a solution will jump out at you before very long.

UNTITLED by Millard Sheets. Watercolor on Arches 300 lb. cold-pressed paper, 22 × 30" (56 × 76 cm). Private collection.

The sensitive painting skills of Millard Sheets are reflected in his designs and colors. Each of his paintings reflects his love of life and all its promise. Emotion and content were his hallmarks.

ROOT SERIES by Katherine Liu. Watercolor on Strathmore 240 high-surface illustration board, 40 × 30" (102 × 76 cm). Collection of Guy Lipscomb.

Here is a great example of the use of repetition with variation. The rhythms here keep your eye occupied for a long time. I keep finding new pathways of visual pleasure as I repeatedly enjoy this piece in my home.

USE ACTION VERBS TO PROD YOURSELF

Written and spoken words can help unlock your visual creativity. Words define and refine thoughts and objectives. Certainly, as mentioned earlier, putting your thoughts into words will help you zero in on what you want to say in paint. Don't neglect other people's written words for ideas. Constantly be aware of painting opportunities as you read. Ideas come from humorous situations, tragedy, news, novels, biographies, history, poetry. I am always searching for ideas, and many times a phrase that appeals to me will has become the title and germ of a picture.

I find it useful to have verbal reminders of options for changing visual images, especially when I know an idea needs further development but haven't decided yet what I want to do with it. All these action verbs involve thoughtful change on your part. Try writing a list of verbs like those that follow, and tacking it up on the wall of your studio where you can see it as you paint. Start by copying this list, and add whatever other verbs inspire you:

distort	eliminate
modify	transcribe
dissect	compress
force	select
elongate	associate
substitute	animate
reassemble	subtract from
twist	shrink
reverse	overlap
rearrange	enlarge
fractionate	dramatize
multiply	reorganize
contract	texturize
combine	tilt
exaggerate	change color
divide	repeat with variation

Each of these action verbs may suggest further subcategories to experiment with, singly or in combination, to the point where the number of possibilities becomes staggering. For example:

Substitute colors, shapes, masses, textures, temperatures, lighting, lines, decorations.

Eliminate edges, masses, objects, shapes, colors, textures, lights, darks.

Exaggerate size, color hue and temperature, perspective, atmospheric effects, line, lighting and value, texture and decorations, edges (lost and found, hard and soft).

Reverse lighting and shadow direction, texture, location, size, color, value relationships, edge treatments.

Combine shapes, textures, masses, color areas, papers (collage), surfaces, images, rhythms.

You really are virtually unlimited as you develop your ideas for a new painting. Playing around with all these possibilities may well help you discover your own special way of expressing yourself—your artistic signature!

MAKE FORCED CONNECTIONS

Put things together that you would never associate in the normal course of existence. If you are really struggling for ways to do this, look around where you are now and jot down nouns naming things you see or recall. Put them in two columns and then pair up words that have little or no connection, disregarding those that have some connection.

The dotted lines all are forced connections. Think on your list of these disassociated things and see what your right brain can do to use the unrelated nouns plus the 32 manipulative action verbs listed earlier to construct a new viewpoint, a new vision for your concept or ideas. There can be forced connections of color, using colors unconventionally on objects in unexpected ways—blue cow, green person, or pink cat.

There can be forced connections in grouping of objects never normally associated with each other in real life or the placing together a composite of ideas, objects, or images associated with an event or place.

Try brainstorming, in which you write down your wildest thoughts in your search for a new way to express yourself. The secrets of successful brainstorming are:

1. Write down all the ideas you can muster about the concept or motif, without judgment. Let them germinate with time.
2. Exhaust your mind of thumbnail designs on the subject going for both quantity and quality.
3. Defer judgment as to what is good or bad until the ideas truly run out.
4. Feel for the best solution. Often creative solutions are subjective.

Logic can solve problems, but creativity often requires thoughtful play. Play with shapes, colors, ideas, materials, and reality. Creativity is really a kind of serious mental play. The "what if" game is basic in the inventive process. "What if we do this?" "What if we change this?" Simple questions like these will change your past ways of doing things more than you think.

Dream and fantasize. These activities may be called unproductive by some, but without this playing with fantasy, no creative work can come into being. Creative artists in any field must get over the feeling that such time is wasted, unproductive, and bad.

SEA AND MEADOW by Edward Betts. Acrylic on illustration board, 14 × 18" (36 × 46 cm). Collection of the artist.

This painting is a fine example of dominance of temperature. See how poetically Betts has used color, texture and shape to create a unified but interesting understatement of realism. The viewer has an exciting time discovering its content.

MORE SOURCES OF INSPIRATION

Inspiration for paintings is all around you. Pay more attention to influences like these:

The language of sound. All sounds have some emotional effect on us. Many painters find that they do their best work when they are listening to a certain type of music. It seems to free them from the world and allows their subconscious minds to function at the highest level of creativity.

The language of emotions. All of us feel a broad spectrum of emotions, but not many beginning painters realize the value of their emotions as they strive to present their feelings in a painting. The brain may be the driver of your paintbrush, so to speak, but I guarantee you this: Emotion is the engine that makes it move!

The language of knowledge. If you have not studied art history, start today and educate yourself. Look *hard* at thousands and thousands of paintings of the present and past. You don't need to reinvent the wheel. You never know when some image or some partial image will kindle an idea of yours. I like to make a written record of something that attracted me. I record it on a loose-leaf drawing page, often making a thumbnail of the concept, and this goes into an idea notebook; I have accumulated a number of them. Later I go through the idea notebooks, select the concept that still has the greatest emotional appeal, and go to work on it. Many of these ideas will never get worked on because I have lost the spark that put them in the notebooks in the first place.

The language of the senses. We have talked a lot already about developing the sense of sight, the painter's eye. Judi Betts suggests in her book *Watercolor—Let's Think About It* (Baton Rouge, Louisiana: Aquarelle Press, 1984) that painters will do well to record in words all the sensations of other senses while using the eyes to record inspirational material for a painting. The smell of newly mown hay, the smell of the sea, the sounds of insects, birds, waves, wind in the trees or grass, the taste of dust in the desert, the smoothness or roughness of the bark on a tree, the silkiness of the sand on the beach, the cragginess of the rocks along the road—all can help you recreate the scene later and will help you appreciate it to a greater degree if you are not painting on the spot.

Every teenager has plucked petals from a daisy. The idea of small sailboats around a dock seemed like a good way to begin. The bird's-eye view of the boats came from a helicopter photo of a marina in Florida. I picked out the ones I wanted and arranged the boat flower with two petals removed.

SHE LOVES ME, SHE LOVES ME NOT. Watercolor on Strathmore 240 high-surface illustration board, 30 × 40" (76 × 102 cm). Private collection.

This piece was shown at the American Watercolor Society. One of the judges later told me that the piece was poorly drawn and not particularly well painted. It violated design principles by having strong elements running out the two lower corners—but it was included in the show because of its unique design viewpoint and concept.

TEN MORE WAYS TO DEVELOP IDEAS FOR PAINTINGS

1. Build your own picture archive of information shapes. Of course, it takes a while to build up substantial information, but it is often very useful and worth the effort. Divide it into three categories:

a. Drawings and sketches. I have most of my small information drawings in loose-leaf notebooks and my larger drawings in flat blueprint files.

b. Photographs and slides. I keep my slides in plastic sheets in loose-leaf notebooks and use the light box to view the pages quickly. I also like to keep prints of my pictures in plastic sheets.

c. Everything else: pictures from magazines, newspapers, brochures, or anywhere I can find material. Using manila folders for each subject (such as trees in winter, trees in fall, trees in spring, people at work, couples, small children at play, and so on) I have filled four file-cabinet drawers full of information. When using material that is not my own, I am careful to change it to a point where I could not be accused of using someone else's image without permission. Remember, borrow but don't steal.

2. Cut yourself a couple of templates with holes of various sizes in them, and move them over your successful and unsuccessful paintings to look for new design and color ideas. Ed Betts, a fine painter and teacher from Maine, shared this idea with me, and I have used it over the years with success. I cut these templates out of manila folders, punch them for my loose-leaf notebook, and keep them with me most of the time. I have also used them on other artists' paintings and magazine photographs as viewfinders, picking up exciting color chords and shape combinations. (When using this technique, remember to borrow and develop in your own way, not steal.)

3. Study natural forms: growing and inert, isolated and in combinations, where you found them and in staged situations. The forms, shapes, edges, colors, and textures are all there in nature, but you have to discover and design from what you find. Hold these natural things in your hand, use a 10× power hand-held magnifying glass, and really explore the natural forms.

4. Discover natural shapes that excite your imagination. For example, cross-sections of rocks

and minerals contain beautiful patterns. The variety of color and shape relationships in nature is virtually limitless.

5. Use pictures or picture segments from your own camera. If you use segments of other people's pictures, make sure you change them beyond recognition; borrow, don't copy.

6. Look at all pictures upside down so as to get an abstract view of shapes, colors, textures, and rhythms. Always be alert for new combinations of interest.

7. Also be alert for activities around you providing situation ideas—people working, enjoying recreation, walking, resting, loving, competing.

8. Get an idea and then pose your subjects, animate or inanimate. If you can't get models, go to your picture archive or the library.

9. Use combinations of information—drawings you have made or photographic material in your files.

10. Engage in thoughtful play with your pencil or brush. Doodle and let the intuitive side of your mind roam free on the page.

This small color study of mine was adapted from a photograph of a girl milking a cow. The tiny postage-stamp-size detail shown became the design basis of the two larger paintings that follow, of two very different subjects. This all goes to show that there is no limit to the possibilities of ideas for paintings, once you begin playing with shapes and colors in your mind.

AT THE FALLS.
Watercolor on
Strathmore 240 high-
surface illustration
board, 30 × 40"
(76 × 102 cm). Private
collection.

*In this painting,
the white shape
that was part
of the Holstein
cow suggested
a waterfall, a
romantic spot for
honeymooners.
The rest quickly
followed.*

TIME IS TUMBLING. Watercolor
on Strathmore 240 high-surface
illustration board, 40 × 30" (102 × 76 cm).
Private collection.

*The other painting became
one of a series on time, with
a clock in the background and
hourglass shapes moving
through space. Time is really
all we have, and I find it
challenging to portray such an
abstract concept in paint.*

RELY ON YOUR IMAGINATION, NOT JUST ON NATURE

Here are some ways to begin a painting without ever being tempted to follow nature. These ideas are well delineated by David Friend in his book *The Creative Way to Paint* (New York: Watson-Guptill, 1986); I am roughly paraphrasing them here.

1. Invent images from dark and light, positive and negative shapes.

2. Color may or may not be important. Start off as Barbara Nechis often begins her pieces by dropping large spots of color onto very wet paper, allowing it to move or tilting or curling the sheet until the shapes suggest a motif. Then she proceeds to develop the shapes into a working picture.

3. Start by dividing the page with lines to suggest the motion and rhythms: long lines, short lines, curved lines, implied or dotted lines. Once you have done this intuitively and are satisfied with the balance, seek out a motif to get you going and expand on it from there. Such a lattice will give you a frame on which to hang your images.

4. Build from basic shapes and lines. Extend lines from the basic shape toward the edge; tie it down and create new negative shapes as you do it. Virginia Cobb from New Mexico does this beautifully in her work.

5. Build a picture from your emotional memory. This has the advantage of not being bound by what is in front of you. It has the disadvantage of having to invent interesting shapes, values, colors, and relationships without a model. You will have to draw on your knowledge, your subconscious computer data bank. Not that you necessarily want exact correctness, but in many cases, especially involving the human form, you can't distort this type of material too far. An abstract will be easier.

Of course, a memory picture can start with a specific goal, unlike the preceding two ways of starting a painting, although that goal may change as the painting progresses.

COPING WITH FRUSTRATION

Frustration can be a tough hurdle. Repeated failure and too much pressure push artists to revert to the safe solutions—usually just what you are trying to transcend! Remember that frustration is an essential ingredient in the creative process. As Rollo May phrased it, "Creativity . . . requires limits, for the creative act arises out of the struggle of human beings with and against that which limits them."

It is amazing how often our plow hits a stump. "I don't know where to go from here! I can't finish it! I'm angry! I'm anxious to finish!" All creative people can relate to these statements. What to do about it?

Go back to basics. The only time I'd recommend holding onto rules of any kind is when you are in danger of drowning. Rules are made to be broken in the creative art world, but this is the time to rely on them.

Back off! Turn the piece upside down. If this doesn't help with the problem, look at it backward through a mirror. If that doesn't work, turn it to the wall and look at it tomorrow or the next day. It's very important to learn to enjoy painting even when things are not going well, for it's in the struggle that we gain our strongest and best insights. The fun of doing, the excitement of the changes taking place under your brush makes time fly, and insight bloom. Don't let your impatience and anxiety to finish force you to move too soon with an inappropriate solution.

DON'T BECOME A VICTIM OF YOUR OWN SUCCESS

If a picture sells and wins in a competition or is praised by the public or a good critic, there is great personal pressure to repeat the idea, concept, or design with variation, of course, and seek continued acclaim or sales. That may be all right, but it can stop an artist's growth and deaden his or her courage to create new, even more wonderful pictures. It's really sad when you see this happening to a person who has been growing and improving, and suddenly it all comes to a screeching halt, and the artist stays on that plateau for years, frozen by one of the many fears we talked about earlier.

Remember, growth requires continued risk!

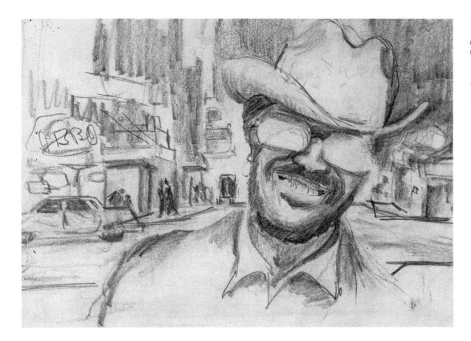

This was my second attempt at a pencil design drawing for Urban Cowboy. *The first version had another figure to the left of the cowboy. I needed to play with the composition until it felt right.*

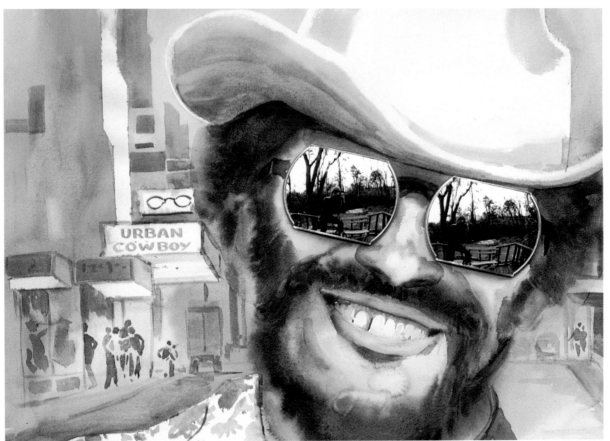

URBAN COWBOY. Watercolor on Arches 140 lb. cold-pressed paper, 28 × 36" (71 × 91 cm). Private collection.

The glasses in this picture are rearview mirrors used by truckers on their big rigs. I liked the idea of making sunglasses out of these shapes. The film Urban Cowboy *was all the rage at the time. I smiled all the way through this painting, and laughed out loud when it was turned down in a local show only to do well in a national show in New York. I adhered the mirrors to the page and painted around them, after I had worked out the composition.*

Cornerstones of
Great Paintings

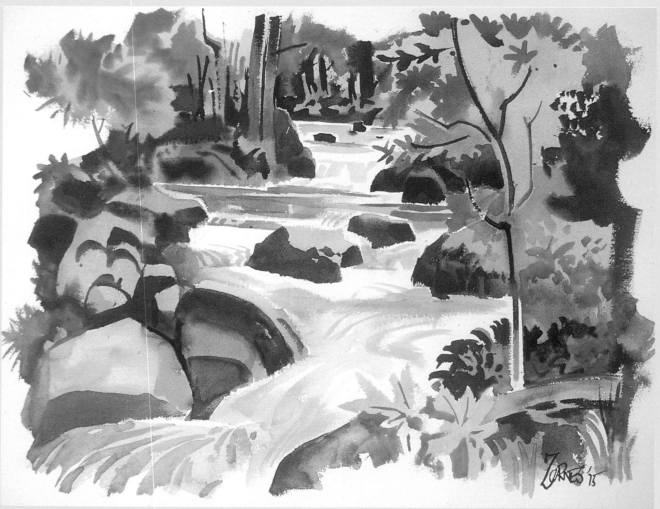

APPALACHIAN STREAM by Milford Zornes. Watercolor on Arches 140 lb. cold-pressed paper, 15 × 22″ (38 × 56 cm). Collection of Guy Lipscomb.

> *"Instinct which nourishes method can often be superior to a method which nourishes instinct."*
>
> —Pierre Bonnard

If you ask yourself, as students often do, whether there any proven concepts or ground rules that you should make a part of designing a picture, the answer is yes. An in-depth understanding of these will help you immeasurably.

The concepts we will be talking about in this chapter should become an integral part of you because they apply to all types of visual art efforts. They have served painters for generations past. I'm greatly indebted to Mateland Grave's fine book *The Art of Color and Design* (New York: McGraw-Hill, 1951), for many of the following thoughts, which I have rephrased in my own words. I'm not saying that you can't violate these principles, but they are very reliable basics.

COMPOSITION

How do you define "composition" or "picture design?" It's easy to be confused by the many definitions in the dictionary. KISS, "Keep It Simple, Stupid," definitely applies to design and painting in watercolor.

In fine art, composition means the putting together or organization of different parts of a painting into a unified harmonious whole. It is deemed acceptable when any additions or deletions would reduce the overall effectiveness of the design. I'm sure every judge would probably see it differently, but judge we must, even though we realize that each painter would come up with a somewhat different answer.

Composition or design has little to do with the subject matter or painting method used by the painter. The design of a painting is the skeleton on which a great painting is built, and the best technician in the world can't make a good painting out of a weak composition. There have been several occasions in which I did well in competitions with paintings that were rather poorly painted or drawn. They held up well with the judges because they had good design as well as an exciting concept and composition. It pays to work very hard on the foundation of your picture.

GRADATION

Gradation creates movement without shape that is just as real as oblique directional shapes or lines. When most students think of using gradation, they think of only two of their options—gradation of value and color—and completely ignore gradation of line, size, shape, direction, and texture. Just think of all the opportunities you are missing to let gradation work to make your piece that much more interesting.

We often forget that we have four options for using gradation in color:

1. Gradation from one color to another, such as from red to yellow.
2. Gradation of value of one color from light to dark.
3. Gradation of temperature of a color from warm to cool.
4. Gradation of intensity or chroma of a color from bright to dull, accomplished by mixing with its complement or black.

Color gradation can be used to create movement without shape. When you learn to use different kinds of color gradation together, color reaches its maximum effectiveness.

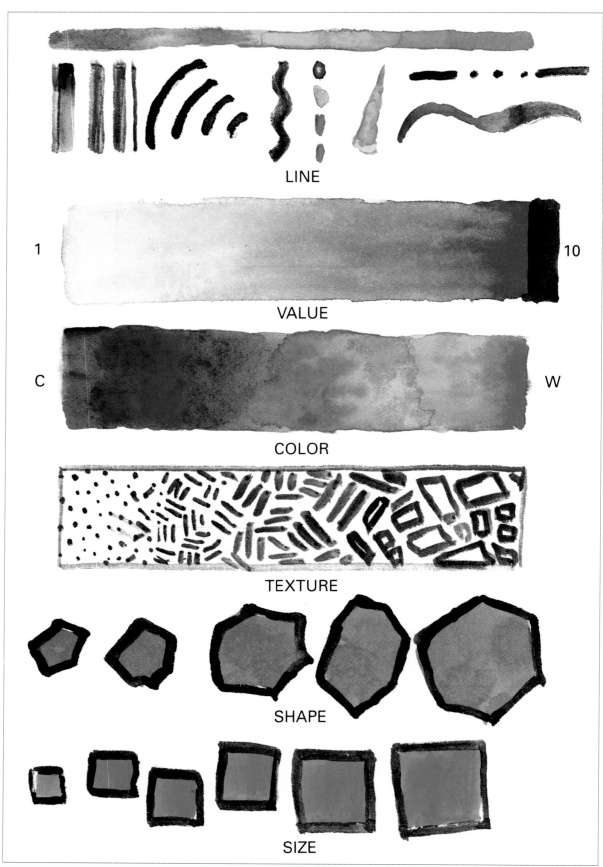

LINE

1 VALUE 10

C COLOR W

TEXTURE

SHAPE

SIZE

Gradation is a powerful tool and can be used with all elements of design.

CHANGE HUE

CHANGE VALUE (WATER ADDED)

CHANGE TEMPERATURE

CHANGE TONALITY (BLACK ADDED)

Here are four ways to achieve color gradation in watercolor.

DOMINANCE

Dominance is a basic principle of aesthetic order. Perhaps more than any other concept, dominance creates unity and harmony in a work. We often think of dominant direction, value, or hue, but how rarely do we use dominance of line, shape, size, and texture? How can you create dominance consistently in your work? Dominance is created most easily in these ways:

1. By repetition with variation of line, size, shape, color, value, direction, and texture. The key words are "repetition" and "variation."

Repetition without change becomes dull in a big hurry, and you should search for ways to repeat all the above tools, changing them each time they are used in the painting.

2. By making one of the competing units in the work (a) larger, (b) greater in contrast of value, (c) stronger in hue or color, (d) more interesting in contour, (e) more exciting in texture, or (f) combinations of these five options. There are probably other options, but if you keep all these possibilities in your brain's computer and constantly examine your compositions accordingly, your designs will improve.

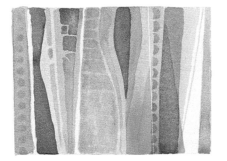

COOL, VERTICAL DOMINANCE

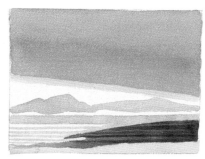

WARM, HORIZONTAL DOMINANCE

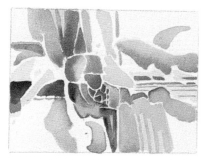

COOL, CRUCIFORM DOMINANCE

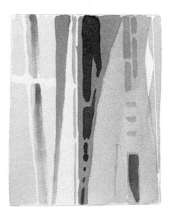

COOL, VERTICAL DOMINANCE

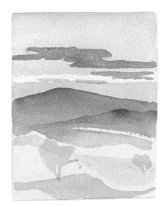

WARM, HORIZONTAL DOMINANCE

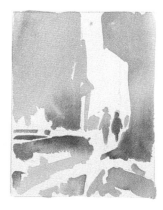

WARM, CRUCIFORM DOMINANCE

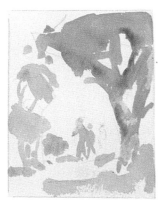

WARM, FRAME-IN-FRAME DOMINANCE

Here are several examples simultaneously showing (1) warm or cool dominance, (2) dominance of different shapes, and (3) dominant design schemes that are horizontal, cruciform, or framelike with partial closure. Only Indian red and ultramarine blue were used in this exercise.

ALTERNATION

One of my teachers, Rex Brandt, made me realize the value of using alternation, which is sometimes called counterchange. He describes the process as "weaving the subject matter into the working surface." The analogy is apt.

Using value alternation binds the shapes to one another to create unity. When alternation has been used effectively, the shapes of the objects never look as if they have been cut out with scissors and pasted onto the working surface. Take a few minutes to study the examples, and then use this principle at every opportunity in your own work.

Changing value, size, color, texture, shape, line, and direction as you design adds life and unity to your work. Don't forget to take advantage of these opportunities.

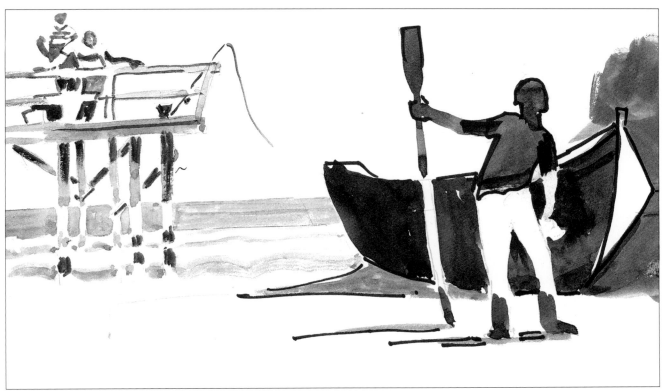

The principle of counterchange or alternation weaves the picture into the page and enhances the illusion of three dimensions. Where the background is dark, make the image light, and vice versa. Use warm backgrounds for cool subjects, and so on.

CONTRAST

There are several hundred options at your disposal in just the one concept of contrast or conflict. How many options have you been using as you plan your designs? With seven basic tools—line, value, color, size, shape, direction, and texture—and seven basic concepts—gradation, repetition, alternation or counterchange, balance, dominance, harmony, and unity—the number of options for creating variety and excitement is enormous, because you can use them in varying combinations in different areas of a composition. I often choose to start my work in contrast or conflict, and resolve it as I go along, hoping that in the end I will provide balance, unity, dominance, and harmony.

The examples on this and the facing page show conflict or contrast. They are not good or bad, only examples of the principle involved.

Conflict of line

Conflict of direction

Conflict of line and direction

Conflict of size and value

Conflict of size and shape

Conflict of direction and shape

Conflict of size and hue

Conflict of size, shape, and value

Conflict of size, shape, value, and hue

BALANCE

Balance is very intuitive and almost a reflex action for most people. When we walk into a room and see a tilted picture, the first thing we want to do is to straighten it. Always remember that a perfectly balanced value drawing in black and white can be totally destroyed by the misuse of color. This is why you must always consider color along with size, shape, and value when you are working out your basic design for a picture. Always remember that one small spot of brilliant color will balance a huge chunk of neutral gray.

BIRD SONGS II.
Watercolor on Arches
140 lb. cold-pressed
paper, 30 × 22"
(76 × 56 cm).
Collection of the
artist.

I enjoy the wild birds outside my studio, and in this painting I decided to accept a real challenge: trying to reduce their songs to shapes. The basic shapes are well placed for balance, with the largest shape slightly off-center, compensated for by the two small shapes on the left and one on the right. I used an airbrush to soften the edges of the "notes."

RHYTHM

Many successful paintings use rhythm to ensure unity and harmony. Rhythm is developed through repetition, and a good time to establish it is in the design stage of your piece.

Think about extensions of each line in your design drawings, whether you are designing a thumbnail sketch or designing with the brush on the working surface. Keep your design instrument moving, extending with a skip of the line that ends at the first object, and on into the second object or shape in the work. These extended lines, whether dark or light, become pathways for the viewer's eye, and if they can be made to turn and return to the design in a circular or elliptical way, they tend to keep the viewer inside your frame, as mentioned earlier. The painting will have greater unity and harmony.

You can also create a depth rhythm, movement into the background and back into the foreground. This is often accomplished by having a foreground object reach into the background space so that viewers go deeper into the painting. They contact a background object and are brought back to the foreground with an overlapping foreground element. What we are really talking about is movement of lines, values, shapes, and colors—both in the plane of the paper and out of the deep space.

Rhythms are formed by values and colors as well as by extension of form and shapes of lines. Repetition of a similar color in several planes of depth will create rhythms. Repeating color to create greater interest will be more effective if you modify the color slightly both in value and temperature.

Modified similar shapes placed at different angles or reversed in different parts of the painting will also create interesting rhythm. These shapes can be real objects or plastic or biomorphic shapes, and the latter may be negative shapes between objects.

Keep the principles of this chapter in mind as you plan your paintings, and you'll be well on the way to doing paintings that appeal to the viewer's eye.

SEEKERS' CONFLICT.
Watercolor on Arches
140 lb. cold-pressed paper,
22 × 30" (56 × 76 cm).
Collection of the artist.

This piece is another in my continuing series entitled "The Seekers." The imagery here is exaggerated and full of action shapes and rhythmical motion, with gestures countering each other for a feeling of freedom and fluidity. These images developed quite spontaneously as I painted. The absence of static horizontal and vertical shapes also contributes to the painting's rhythms.

Becoming a Better Judge of Your Own Work

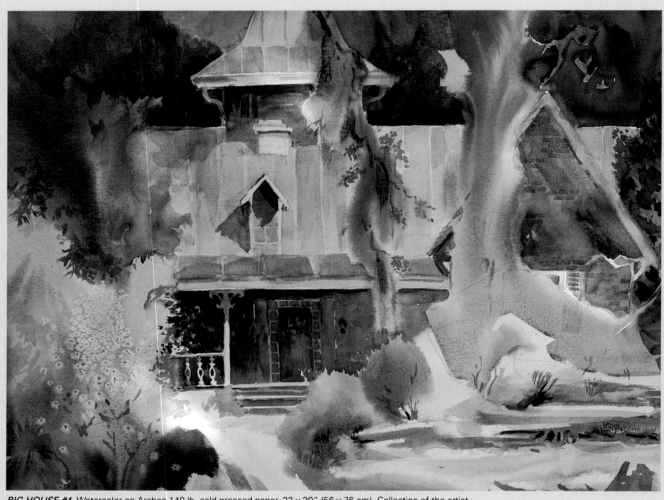

BIG HOUSE #4. Watercolor on Arches 140 lb. cold-pressed paper, 22 × 30″ (56 × 76 cm). Collection of the artist.

> *"I cannot give you a formula for success, but I can give you the formula for failure. Try to please everybody."*
>
> —Herbert Bayard Swope

Although it is undeniably difficult to judge your own work, all painters must judge the progress of their paintings as they are working, as well as when a piece is completed. There is no magic shortcut to developing this ability, but here is a summary of some steps you can take in the right direction.

KNOW THE PRINCIPLES OF DESIGN AND COLOR

The better you understand the principles and elements of design, the better you will be able to judge your own paintings. Work with the principles of design and color until they are thoroughly familiar to you—until you use them subconsciously in every painting. Earlier chapters of this book will get you off to a good start in both these areas.

STUDY ART HISTORY

Your own weaknesses and strengths are more apparent if you have acquired knowledge of the work of the masters and the best of contemporary painters. As you study the work of the best, notice how they solved their problems:

- How they created space with values, forms, and colors
- How they avoided monotony
- How they created action, movement, and rhythm
- How they created mood with shape, line, color, texture, and direction
- How they created pathways for the eye through their work

STUDY YOUR OWN SUCCESSES AND FAILURES

It is great fun to be lucky and pull off a fine painting, but luck won't last. Remember that you learn much more from your failures than from your successes. Constantly study and compare your own successes and your failures in competitions with the work of painters who have built credibility over the years.

The volume of work and the discipline of regular drawing and painting is far and away the key to your quality work in the future. One of my first teachers, Jack Pellew, used to say that if you haven't discarded 500 pieces of watercolor work, you haven't begun to understand the medium.

KEEP AN INDEPENDENT VIEWPOINT

Painting without concern for what one's peers will think is one of the most difficult things for a painter to do. It's very easy to fall into a position where what you create is little more that a shrewd composite of what everyone else is doing or represents a safe middle position at the center of several conflicting contemporary points of view. Every creative painter must find his or her own unique painting voice and acquire the technical skills and vocabulary to express that personal voice.

CROSS-EXAMINE YOUR PAINTINGS

Doug Walton of Louisiana Tech made me aware of one of his techniques for examining his work. He exposes only the edges, one at a time, covering the rest of the painting. These questions are asked of each edge:

1. Are edge shapes and spaces monotonous?
2. Do values change too abruptly from light to dark, with too few middle values?
3. Are lights and darks on the edge too explosive, thus expanding off the edges of the piece and leading the eye out of the picture?
4. Are the edges entertaining?

After the edges, expose only the corners and ask the same questions. Remember, corners are natural focal points. They are where the tallest vertical and the longest horizontal meet.

Another question you must constantly answer yes to is: "Am I listening to what's happening in the painting?" In order to do this, you must back off

and see it from 10 feet (3 meters) or so at regular intervals. This will allow your painting to talk to you.

Constantly play the "too" game with your painting: Is it too warm? too cool? Is it too dark? too light? Is it too static? too active? Is it too hard-edged? too mushy? Is it too fractured? too predictable? Is it too cluttered? too simple? Also consider the answers to the following questions as you evaluate a painting's progress:

1. Is the idea really worth conveying to others?
2. Am I giving the viewer a new vision of the idea?
3. Does the painting express the mood I intended?
4. Does the color chord complement the desired mood?
5. Which areas are working and which are not?
6. Does dominance prevail in color or temperature?
7. Does the painting possess a dominant motif or shape?
8. Does it possess various and interesting secondary motifs?
9. Are both the primary shapes and secondary shapes repeated similarly in different sizes? (Have I achieved "repetition with variation," as Ed Whitney would phrase it?)
10. Are the negative shapes interesting in their own right?
11. How well is the painting unified in color, shape, and value?
12. Do the small shapes work well with the large ones, or are they spotty?
13. Does the painting need more texture? Less?
14. Are there passages of light or dark leading the viewer's eye through the piece?
15. Are the various depths in the work woven together well, avoiding an appliquéd look?
16. Is the transition between subject and background subtly done?
17. Are the colors clean and beautiful in the places of importance?

Do these questions cause you to take a long second look at your picture? Asking the right question is often more than half of finding the right answer.

Don't get discouraged if you are always finding problems in your paintings. I have been painting for many years, teaching for a lot of those years, and I consider myself a very serious painter. I still can't give satisfactory answers to all those questions about a single painting I've done. There's always something that I could have done better. That's what keeps me humble, eager to begin a new painting and continuously seeking to grow as a painter.

GO BACK TO BASICS
When I find myself unhappy with my work, I go back and refresh myself with the basics and recharge my batteries. Teaching often has this effect. As stated by Lamar Dodd, a noted painter and former head of the University of Georgia Art Department, "Students provoke thought and certainly aid in clarifying one's own ideas."

ENTER COMPETITIONS
If you feel good about a piece of work, test its merit in several strong competitions before asking any local qualified artist to critique it, and see what happens. If it is turned down several times by good judges, it probably has weaknesses you haven't realized.

I have made it a rule never to show a painting to anyone if I intend to send it to a competition. That way, if the painting is successful, I know that what I sent was 100 percent mine! I made this policy some years ago when I got a painting into a regional competition with the help of my good friend and teacher Alex Powers, who said, "Guy, the eye on the far side of the head is too strong!" One stroke with a wet sponge corrected the problem and it was accepted in the competition. I realized that it never would have made it if Alex had not made that one statement of judgment. I am convinced that this policy in my work has improved my ability to judge my own work.

Consider what judges are looking for. Many ask:

1. What is the painter trying to say? (What is the concept or idea behind the painting?)
2. Has he or she said it effectively?
3. Does the painting have life? Is it dynamic or tranquil?

4. Does the painting have good or bad composition?

5. Does its overall design work?

6. Is the paint quality good?

7. Is there evidence of good technical skills in the painting process?

8. Does it have emotion, feeling?

9. How is it presented? Is it poorly framed or matted?

All these factors have an effect on judges, and you should keep them in mind as you paint—even if at that point entering a competition is the furthest thought from your mind. (You never know how well your painting may turn out.)

Remember, rejection slips are no disgrace! Take them for what they are: one person's opinion. If you disagree, try several more competitions. I have been turned down in local shows only to win awards with the same piece in national open competitions. Rejection slips are useful in more than one way; I am making an unusual collage with mine.

TAKE ADVICE FROM THE PROS

Here are some tips on judging your own work from a few of the painters I admire most.

Everett Raymond Kinstler suggests that to become a better judge of your own work, you should concentrate on knowing the reasons you don't like the piece as well as the reasons you do. Ray works very hard to make his work look easy.

Here are some tips I picked up during an interview with Lamar Dodd: "Be honest to what you are and know—don't try to fake it or copy when it is not you. Don't destroy your work quickly if you are not happy at that moment with it. It may be better than you think! It's very hard to be a good judge of one's own work."

And finally, a thought from Rex Brandt: "You can easily fall into the trap of wanting to follow the same course as other professionals, but you can't beat them at their *own* game! You have to be true to your own feelings and emotions."

All this is advice well worth listening to and applying to your own work.

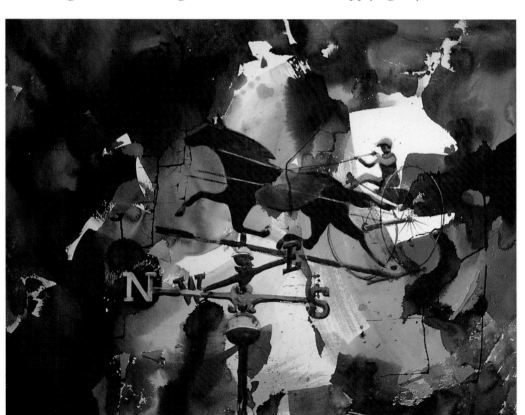

NORTHWESTERLY.
Watercolor on Strathmore 240 high-surface illustration board, 30 × 40" (76 × 102 cm). Collection of the artist.

The underpainting for this piece suggested a turbulent, stormy sky with a lot of wind, so I chose to paint the weathervane on top of my studio building. The oblique angles in the design help convey the buffeting action of the wind.

This painting contains conflict but also unity and balance. The further you progress with painting, the more these design principles become an intuitive guide that lets you evaluate your own work.

Questions Often Asked

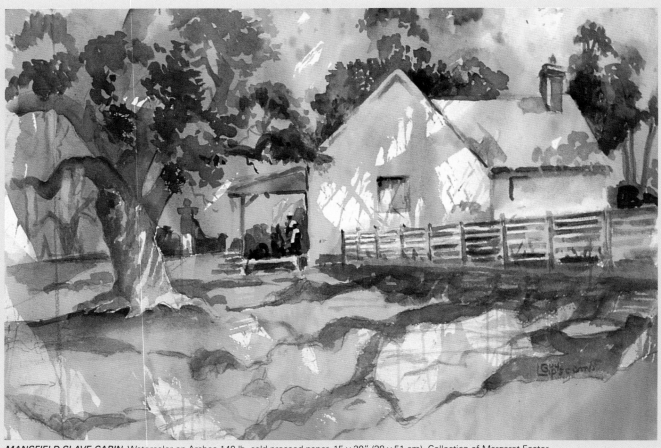

MANSFIELD SLAVE CABIN. Watercolor on Arches 140 lb. cold-pressed paper, 15 × 20" (38 × 51 cm). Collection of Margaret Foster.

> *"You can easily fall into the trap of wanting to follow
> the same course as other professionals but you can't beat
> them at their own game!"*
>
> —Rex Brandt

(1) How can I overcome the fear of failure?
Every painter has this worry, regardless of expertise.
The key is to push it back and not even think of
that possibility. Let your enthusiasm for the
excitement of discovery and freedom of expression
drown all fearful thoughts and brushstrokes. In
watercolor, it's only a piece of paper. You can
always wash it or gesso it or turn it over. You have
nothing to lose and all to gain.

*(2) What if I don't have access to art school and
expert teachers? How do I start to paint in
watercolor?*
You still can go far if (a) you have a consuming
desire to create in paint, and (b) you are willing to
read, study, practice, and paint regularly. Without
this difficult discipline you can only go part of the
way. Knowledge can be acquired alone, but there is
no substitute for constant, thoughtful, regular effort.

Here are just a few of those who did very well
mostly on their own: Winslow Homer, Milton Avery,
Ben Stahl, James McNeill Whistler, Paul Gauguin,
Vincent van Gogh, Maurice de Vlaminck, Maurice
Utrillo, Henri Rousseau, and Grandma Moses. You
can too! You can learn much from art history and
from exhibits, as well as from many fine books
written by good teachers.

(3) Should I strive for speed in watercolor?
Technical cleverness is a real danger. The fastest
brush will often race ahead of emotion and content,
using tricks and cliché solutions. Such an artist may
impress the onlookers during the painting
demonstration, but the paintings seldom have
staying power. Never let your technical skill outrace
the emotional content of your work.

*(4) How much preparation time should I spend
before beginning a serious painting?*

Each painter will vary on this question. Judging from
their drawings and studies, most of the masters of the
past and some of the present do a lot of preliminary
work. Looking recently at Andrew Wyeth's Helga
show, I was struck with the amount of preparation
he did for each egg tempera. Many experienced
painters today do little preparation and dive in,
leaning on the subconscious to carry them forward.

*(5) Should I paint whatever excites me at the
moment?*
The novelty of new forms, shapes, colors, textures,
and relationships is a great motivation, but if you
are a new painter, there is also a danger of
overenthusiasm outstripping your knowledge of the
material. If you study your material and let your
ideas incubate first, your success ratio is bound to
improve. Resist jumping into the subject too
quickly, especially if you are a new watercolorist.

*(6) Why are my sketches or colored cartoons more
interesting than my finished work?*
It is not uncommon for artists to overdevelop their
final efforts, while their preliminary work is full of
spontaneous freedom and feeling. If you have this
difficulty, try stopping work on each serious piece
before you normally would, putting it on your
easel, and looking at it for at least one or two days
while you work on your next piece. You will make
better decisions going this route. (See also question
18 in this chapter.)

*(7) How can I get more life and action into my
work?*
You can always animate your work by distortion,
tensions, and exaggeration. Unpredictability is also
useful; seek the unexpected in shape, value, color,
direction, size, and texture. Texture, spatter, and
fresh clean color passages will help too.

(8) *If I use really bad judgment in color, value, size, or shape as I begin a piece and realize that I've bombed early, should I try to repair and recover the piece, or should I start over?*

Start over on a new sheet! There is no way to recover a piece of watercolor that is really unsatisfactory.

Don't destroy the bad start, however. Wash it off, let it dry, and paint over the residue image, or turn it over and paint on the other side. After several unhappy tries, you can always gesso both sides and start over again and again.

(9) *How can I keep from destroying a picture that is well along and has good areas but some unresolved areas?*

- Paint pieces of paper in colors and values you are considering for the problem spots. Using scissors, cut out shapes of the colored papers and place them on your work so that you can judge how those colors would look.
- Get a sheet of water-wettable acetate or Mylar. Place it over your work and paint directly on it so you that you can change values or colors. Either of these techniques allows you to test various colors and values without touching your work.

(10) *What's wrong with painting in a group? I enjoy the company.*

The problem is distractions. Painting is a very lonely, thoughtful, exhilarating job. In watercolor things are happening altogether too fast on your sheet. You cannot tolerate any distractions.

(11) *Is there a danger in having too much imagery?*

If your goal is a pattern design, the answer is no, but if you have a central theme in your work, you can easily overpower your main idea with too much imagery. Of course, value, size, and color have a great effect on the dominance you want, probably even more than the number of images.

(12) *What are ways to subdue areas that are too strong in value and color in a watercolor painting?*

Lifting is probably the easiest way to correct this, but a collage of thin rice paper over the strong area will so the same thing. (Apply the rice paper with diluted acrylic matte medium.) A wash of a neutral will also push back color that is too strong.

(13) *How can you get random varied lines easily in watercolor?*

In order to get dynamic marks in areas needing texture and movement, cut a strip of mat board into various lengths. Using the edges dropped into a variety of wet color on your palette, transfer the shapes of mat board edge to your painting. This printing technique can be used with ferns, flowers, leaves, grasses, stencils, even your hands!

Slinging paint has a similar effect—it provides action in static areas. A long-haired oriental brush with natural fibers is an ideal tool for throwing watercolor in discontinuous dotted lines. Practice first.

(14) *What are the advantages of putting more than one color into your brush?*

The big advantage is that the colors blend as they are applied to the paper, not on your palette. This results in unexpected, fresh color passages not easily obtained in separate brushstrokes. With a flat brush 1" or 2" (2.5 or 5 cm) or wider, you can load more than two hues and obtain many interesting graded passages with a little practice.

(15) *What are ways to reserve or recover light areas in watercolor?*

In pure watercolor, lights become precious and must be preserved or often recovered. White paper sings and expands!

Techniques to reserve whites:
- Paint around the white area.
- Mask with masking fluid.
- Use masking or drafting tape cut with an X-Acto knife or scissors. Drafting paper tape is the easiest to use because the watercolor does not flow into or around it; the tape also comes off cleanly. Remove it slowly and as soon as possible after the painting is dry. Masks can also be cut from paper or film.
- Lay a sheet of regular waxed paper over your painting, and draw over it with dull pencil or ballpoint pen so that the design is deposited in wax onto the painting sheet. As explained earlier, this works best on smooth paper with fine lines that you want to stay white. When you paint over the area with color, the transferred design will not be wet and will remain white.

To recover whites, rated by degree of paper disturbance:

- Wet the area with clean water and a small watercolor brush and lift with facial tissues. This is least damaging to the paper.
- Using tape or a precut mask, use a prewet and squeezed cosmetic sponge to bring back the lights.
- Wet the area with clean water and scrub lightly with a small bristle brush. Use facial tissues to lift loosened color.
- Use a hand-held ink eraser and mask off surrounding areas with masking tape. This damages the paper but takes you back to white.
- Use an electric eraser with ink eraser filler. If you sharpen the eraser by making it flat on sandpaper, you can cut very fine white lines.
- Use white pastel chalks to cover areas that are too dark.
- Use gouache or opaque Chinese white or acrylic to cover dark areas. Both gouache and Chinese white are water-removable, but you must use rubbing alcohol or acetone to remove acrylic white.
- Cover dark areas with white gesso.
- Collage with white paper using matte medium (diluted with 1/3 water) as your adhesive.

(16) *In lifting out color prior to changing hue in that area, should only clean water be used?*
Some painters advocate wetting the area to be lifted with the replacement color rather than clean water, realizing that you are changing color even as you lift the unwanted color.

(17) *How can I tell when a painting is finished?*
You stop at interesting places. You stop when additions would not be additive. That sounds easy, but it's always going to be a judgment call by the artist. Most watercolor paintings are done rather rapidly. On the other hand, many artists adjust and adjust as long as they have access to the work. I know I've worked on pieces that were years old!

The best way to make a good call is to let it sit on the easel for a while before making a decision. I find almost every piece requires change and adjustment after I think it's done. Looking at it afresh each day will reveal problems you did not see during the creation of the painting. Sometimes it may take only one swipe with a moist sponge to

soften a prominent edge or line and correct the problem. Don't frame it prematurely! All too often I find something wrong in one of my paintings as soon as it's been framed.

(18) *Should I paint the same drawing more than once? What are the advantages and disadvantages of working in a series?*
Don't paint from the same drawing more than once unless you have something new or different to say about it. However, some artists find a subject that inspires them again and again. Claude Monet did, with great success. Remember that none of his waterlily paintings are copies; each scene conveys a different light, a different mood.

A series of paintings shows the viewer that your work has a consistent quality. This is very important if you are selling through dealers or galleries. If your pieces look like a group show, with no continuity in style or content, you may be considered versatile but unpredictable by the gallery owner, and you will have a hard time developing customer loyalty. Besides, the really best reason for working in series is the belief that each piece will be better than the last, and real growth will occur.

I often begin a series by making many three-value thumbnail compositions. All the preliminary thought and effort I do increases my chance of success, but I never try to anticipate the finished product. Often the piece in progress suggests the next painting.

Katherine Liu, a fine painter and teacher who has done a number of striking series, suggested a way of keeping them on track. Put your design value sketch, and photos of the paintings finished so far, where you can see them as you work. Then continually ask yourself, "How will this next idea and piece add to my series?" and "Am I merely repeating myself, or do I have something new to say?"

(19) *How do I know whether I'm successful?*
This is gnawing question. The answer is *not* sales; some of the worst painters are financially successful, whereas van Gogh was a financial failure! I think you are successful when you please your changing self. It's nice to have acceptance by your peers, but ultimately you are the person whose approval will bring you the most satisfaction.

Conclusion: Where Do You Go from Here?

BYGONE. Watercolor on Arches 140 lb. cold-pressed paper, 22 × 15" (56 × 38 cm). Private collection.

> *"Tenacity you must have! Be true to yourself, learn by your mistakes and you will succeed!"*
>
> —Everett Raymond Kinstler

So far we have talked a great deal about watercolor and about art in general—ways you can improve your drawing skills, ways to give fresh life to your watercolor paintings. But now that we have reached the end of the book, it's time to ask what you want to do with the knowledge you have gained. This chapter will give you a brief look at some of your options.

PLANNING IS INVALUABLE

Having developed a research and chemical manufacturing business for some years, I learned the value of planning. The *process* of planning, not necessarily the plan itself, is the key. The plan will change along the route, but the act of planning brings things into focus for all your objectives. Of course, you must follow the plan.

If you plan, set a goal of improving your technical skills, then set time goals and actions required. These might be classes required, books to be studied, drawings to make, paintings to be completed, shows to be entered, and so on. The lifelong adventure has begun! There are few shortcuts to excellence. You can become a good technician in a few years, and from there only you can tell how far you can go. It's never too late to begin, so start now!

If you are serious about painting, set your goals as a painter and take them seriously. Also set goals for other areas of your life, because obviously they are all intertwined. You will have to set one-year and five-year priorities, because if you try to pursue all your dreams simultaneously, you will trip over your own feet. Be realistic, and this is harder than it sounds. Answer questions like these, and any others that may occur to you:

Who do I want to be?
What do I want to do?
What do I want to have?
What do I want to see?
What do I want to share?
What am I doing to reach each goal?

The more centered you are within yourself, the more certain you will feel about the answers to these kinds of questions. Follow up on your own progress. You will be glad you did! Keep a chart for your eyes only.

A QUESTIONNAIRE

Art can play whatever role you like in your life. Perhaps you want it as a mild hobby, or perhaps it is a consuming passion. Perhaps you would like to earn a living at it as a painter or teacher or in some other way—for there are many possibilities. Here are some questions for you to think about:

1. Do you want to paint just for your own pleasure?
2. Do you want to sell your paintings?
3. Do you want to send paintings to competitions to test your skills?
4. Do you want to teach painting?
5. Do you want to be recognized by your peers by being selected to become a member of art societies and recognized art clubs?
6. Do you want to try to be in the big museums and the art history books?
7. If you want to paint to sell, how much do you want to earn per year?
8. How many paintings must be completed and sold at what price to reach the sales goals you have set?
9. How much time can you give to your artwork per week? This will help answer question number 8. How much time do you waste per day?
10. How much time per week can you give to the study of art in all its aspects?
11. How well do you know yourself and what you really want?
12. Painting is a lonely business. Do you like working absolutely alone? If your honest answer to this question is no, don't try to take your painting too seriously.

BECOMING A PROFESSIONAL PAINTER

If you have reached the point of wanting to make a livelihood of painting, you must become a business manager as well.

Most painters dislike the business side of art and as a result don't do well at it. But if you are selling at all, you immediately put yourself in the business world of marketing yourself and your work, collecting and dispersing sales taxes, pricing, and figuring out sales strategy. You will also have to deal with customer relations, gallery and agent decisions, taxes, overhead, travel, telephone bills, public relations, materials cost, photography costs, licenses, and so on. This is a new ball game.

I have included here a simple five-year business plan working backward from the bottom line—your annual cash needs. $50,000 gross income sounds like a reasonable goal, but when you deduct your expenses for the year, you will probably find that you will not have what you need left to live on comfortably. But remember, this is a five-year goal, and you must walk before you can run, so don't be discouraged. Such a budget will tell you how much painting you must do to reach your goal, how many sales must be made, and so on.

If you decide to use agents or gallery representation, you will have to allow for paying their commissions before anything comes to your account.

The first marketing decision you must make is, "What is the logical market for what I like to do?" And second, "How do I best reach that market?"

Smaller spaces are normally the niche for watercolor pieces, simply because of the physical size of the work normally done in watercolor. Offices, homes, restaurants, and businesses pretty well cover the market. A great many painters have magnified their coverage of their markets through the use of reproductions. Marketing reproductions is highly competitive but can be done. If you try to do it yourself, it cuts heavily into your production time for original work. If you find a good selling agent for your reproductions, you are fortunate, and this would be one desirable way to market your reproductions, freeing you to paint. Reproductions reach a broad market with a great variety of painting knowledge. Representational work is in great majority. As soon as you get into nonrepresentational work, you lose most of your buyers.

How do you go about getting proper sales and marketing representation? First, you have to build a body of representative work. All the sales outlets that might be interested in you want to know whether they can count on a continuous supply of quality work from you. You need a portfolio to show and several sheets of good slides of your work. You need to do your homework on the galleries before you decide to trust your work to them. They are among the most undercapitalized businesses around, and there are many sad tales of artists losing their work or never being paid.

If you are serious about a business in art, you should read *The Business of Art* by Lee Caplin (Englewood Cliffs, N.J.: Prentice-Hall, 1982) or *Art Marketing Handbook*, 5th rev. ed., by Calvin Goodman (Los Angeles: Gee Tee Bee, 1985). Both are good and cover many things you need to know. Here are just some of the nonpainting things a pro has to do.

1. Keep records. Maintain a budget. Determine and meet start-up cash requirements.
2. Determine strategy for marketing, sales, and public relations. Obtain any necessary printed material.
3. Obtain all necessary licenses and insurance. Fill out tax forms.
4. Decide how to present your work. Have paintings framed and/or photographed for slides. Prepare your resume and portfolio.
5. Manage purchasing and inventory of supplies.
6. Protect yourself against health hazards.
7. Read books on the business of art. Learn how to protect yourself from fraud and unfair pricing. Investigate galleries and dealers carefully before selecting them.
8. Maintain control of your original work. You always want to be able to photograph your own work after it's sold. I suggest a stamp on the back of the painting: "This is an original painting by [Your Name], who retains all rights to reproduction and reasonable access for photographic purposes."
9. Oversee making of posters and reproductions if desired.
10. Plan your estate. Get professional help with this one; the IRS will try to evaluate all unsold art.

Bibliography

Albers, Josef. *Interaction of Color.* New Haven, Conn.: Yale University Press, 1963.

Batt, Miles. *The Complete Guide to Creative Watercolor.* Fort Lauderdale, Fla.: Creative Art Publications, 1988.

Berger, John. *Ways of Seeing.* New York: Penguin Books, 1977.

Betts, Edward. *Creative Landscape Painting.* New York: Watson- Guptill, 1978.

———. *Master Class in Watercolor.* New York: Watson-Guptill, 1979.

Biggs, Bud, and Lois Marshall. *Watercolor Workbook.* Cincinnati: North Light Books, 1987.

Birren, Faber. *Color and Human Response.* New York: Schiffer, 1987.

———. *Creative Color.* New York: Schiffer Co., 1987.

Brandt, Rex. *Seeing with the Painter's Eye,* 2nd ed. New York: Van Nostrand Reinhold, 1984.

———. *Watercolor Techniques and Methods.* New York: Van Nostrand Reinhold, 1977.

Bridgman, George B. *Bridgman's Life Drawing.* New York: Dover Publications, 1971.

Brommer, Gerald F. *Landscapes.* Worcester, Mass.: Davis Pub. Inc., 1977.

———. *Transparent Watercolor: Ideas and Techniques.* Worcester, Mass.: Davis Publications, 1975.

Brooks, Leonard. *Painting and Understanding Abstract Art.* New York: Van Nostrand Reinhold, 1980.

Caplin, Lee E. *The Business of Art.* Englewood Cliffs, N.J.: Prentice Hall, Inc., 1982.

Carlson, John F. *Carlson's Guide to Landscape Painting.* New York: Dover Publications, 1973.

Chevreul, M.E. *The Principles of Harmony and Contrast of Colors and Their Application to the Arts.* New York: Van Nostrand Reinhold, 1967.

Cobb, Virginia. *Discovering the Inner Eye.* New York: Watson-Guptill, 1988.

Couch, Tony. *Watercolor: You Can Do It!* Cincinnati: North Light Books, 1987.

Crawford, Tad. *The Visual Artist's Guide to the New Copyright Law.* New York: Graphic Arts Guild, 1978.

Dobie, Jeanne. *Making Color Sing.* New York: Watson-Guptill, 1986.

Edwards, Betty. *Drawing on the Right Side of the Brain.* Los Angeles: J.P. Tarcher, Inc., 1979.

Edwards, David. *How to Be More Creative.* Los Satos, Cal.: Occasional Productions, 1978.

Ellinger, Richard G. *Color Structure and Design.* New York: Van Nostrand Reinhold, 1980.

Faigin, Gary. *The Artist's Complete Guide to Facial Expression.* New York: Watson-Guptill, 1990.

Friend, David. *The Creative Way to Paint.* New York: Watson-Guptill, 1986.

Goldsmith, Lawrence C. *Watercolor Bold and Free.* New York: Watson-Guptill, 1980.

Goldwater, Robert, and Marco Treves, eds. *Artists on Art: From the Fourteenth to the Twentieth Century.* New York: Pantheon Books, 1974.

Goodman, Calvin J. *Art Marketing Handbook,* 5th rev. ed. Los Angeles: Gee Tee Bee Press, 1985.

Graham, Donald W. *Composing Pictures.* New York: Van Nostrand Reinhold, 1983.

Graves, Maitland. *The Art of Color and Design.* New York: McGraw-Hill Publications, 1951.

Grillo, Paul Jacques. *Form, Function and Design.* New York: Dover Publications, 1975.

Guptill, Arthur. *Watercolor Painting: Step by Step.* New York: Watson-Guptill, 1985.

Hale, Robert Beverly. *Drawing Lessons from the Great Masters.* New York: Watson-Guptill, 1989.

Hawthorne, Mrs. Charles W. *Hawthorne on Painting.* New York: Dover Publications, 1988.

Henning, Fritz. *Concept and Composition.* Cincinnati: North Light Books, 1983.

Henri, Robert. *The Art Spirit.* New York: Harper & Row, 1984.

Hill, Tom. *Color for the Watercolor Painter.* New York: Watson- Guptill, 1982.

Hoffman, Hans. *Search for the Real.* Cambridge, Mass.: M.I.T. Press, 1967.

Itten, Johannes. *The Art of Color.* New York: Van Nostrand Reinhold, 1973.

———. *The Elements of Color.* New York: Van Nostrand Reinhold, 1970.

Jamison, Philip. *Capturing Nature in Watercolor.* New York: Watson-Guptill, 1985.

———. *Making Your Painting Work.* New York: Watson-Guptill, 1988.

Kautzky, Ted. *Ways with Watercolors.* New York: Simon & Schuster, 1977.

Leeland, Nita. *Creative Artist.* Cincinnati: North Light Books, 1990.

May, Rollo. *The Courage to Create.* New York: Bantam Books, 1976.

Millard, David. *The Joy of Watercolor.* New York: Watson-Guptill, 1992.

Nachmanovitch, Stephan. *Free Play.* Los Angeles: Jeremy P. Tarcher, 1990.

Nechis, Barbara. *Watercolor—The Creative Experience.* Cincinnati: North Light Books, 1984.

Nicolaides, Kimon. *The Natural Way to Draw.* Boston: Houghton Mifflin Co., 1975.

Pike, John. *John Pike Paints Watercolors.* New York: Watson-Guptill, 1978.

———. *Watercolor.* New York: Watson-Guptill, 1973.

Porter, Albert. *Expressive Watercolor Techniques.* Worcester, Mass.: Davis Pub., 1982.

Powers, Alex. *Painting People in Watercolor.* New York: Watson-Guptill, 1989.

Reep, Edward. *The Content of Watercolor.* New York: Van Nostrand Reinhold, 1983.

Reid, Charles. *Figure Painting in Watercolor.* New York: Watson-Guptill, 1989.

———. *Flower Painting in Watercolor.* New York: Watson-Guptill, 1986.

———. *Painting What You Want to See.* New York: Watson-Guptill, 1983.

———. *Portrait Painting in Watercolor.* New York: Watson-Guptill, 1989.

———. *Pulling Your Paintings Together.* New York: Watson-Guptill, 1991.

Salemme, Lucia A. *Color Exercise for the Painter.* New York: Watson-Guptill, 1979.

Schink, Christopher. *Mastering Color and Design in Watercolor.* New York: Watson-Guptill, 1981.

Schmalz, Carl. *Watercolor Lessons from Eliot O'Hara.* New York: Watson-Guptill, 1980.

Shahn, Ben. *The Shape of Content.* Cambridge, Mass.: Harvard University Press, 1957.

Simon, Howard. *Techniques of Drawing.* New York: Dover Publications, 1972.

Sloan, John. *The Gist of Art.* New York: Dover Publications, 1977.

Sterberg, Harry. *Composition.* New York: Pittman Publication Co., 1950.

Strisik, Paul. *Art of Landscape Painting.* New York: Watson-Guptill, 1985.

von Oech, Roger. *A Whack on the Side of the Head: How to Unlock Your Mind for Innovation.* New York: Warner Books, 1988.

Watson, Ernest W. *The Art of Pencil Drawing.* New York: Watson-Guptill, 1985.

Webb, Frank. *Watercolor Energies.* Cincinnati: North Light Books, 1983.

———. *Webb on Watercolor.* Cincinnati: North Light Books, 1990.

Whitney, Edgar. *Complete Guide to Watercolor Painting.* New York: Watson-Guptill, 1974.

Williams, Hiram. *Notes for a Young Painter: Revised and Expanded Edition of a Classic Handbook for Beginning Artists.* Englewood Cliffs, N.J.: Prentice-Hall, 1984.

Williams, Robert, and John Stockmyer. *Unleashing the Right Side of the Brain: The LARC Creativity Program.* New York: Viking Penguin, 1987.

Wood, Robert E., and Mary Carroll Nelson. *Watercolor Workshop.* New York: Watson-Guptill, 1974.

Index

Edited by Candace Raney and Janet Frick
Designed by Areta Buk
Graphic production by Ellen Greene
Text set in 10.5 point Garamond